The Hakima
A Tragedy in Fez

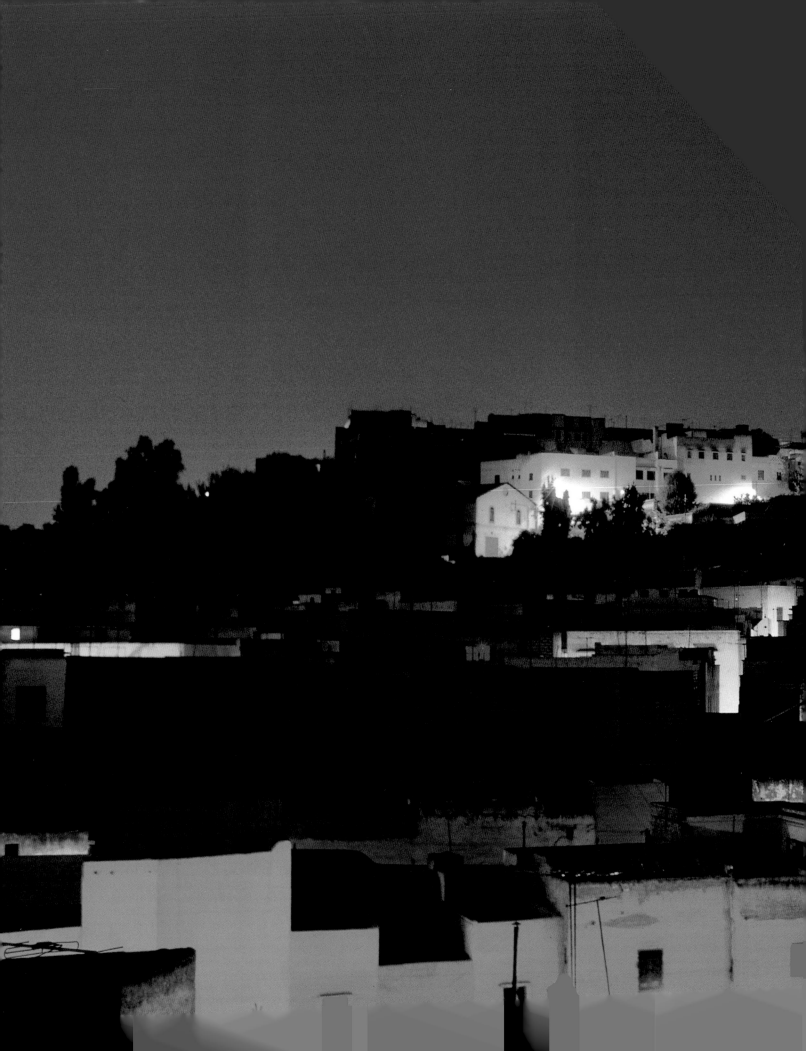

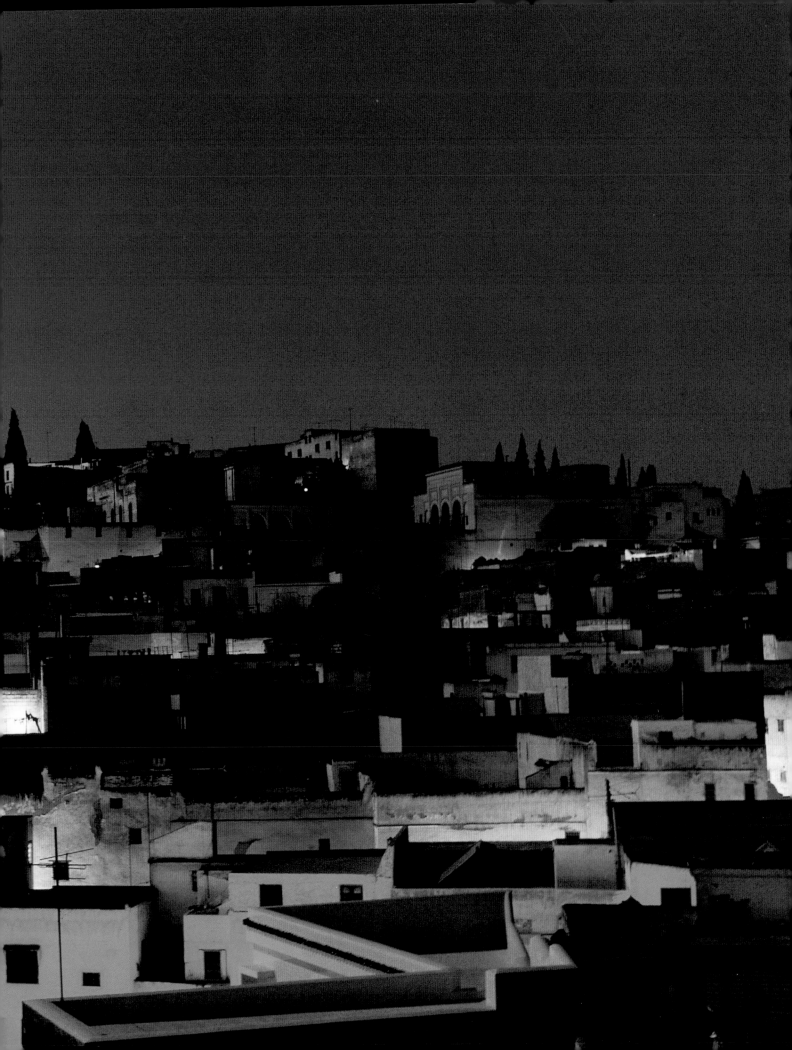

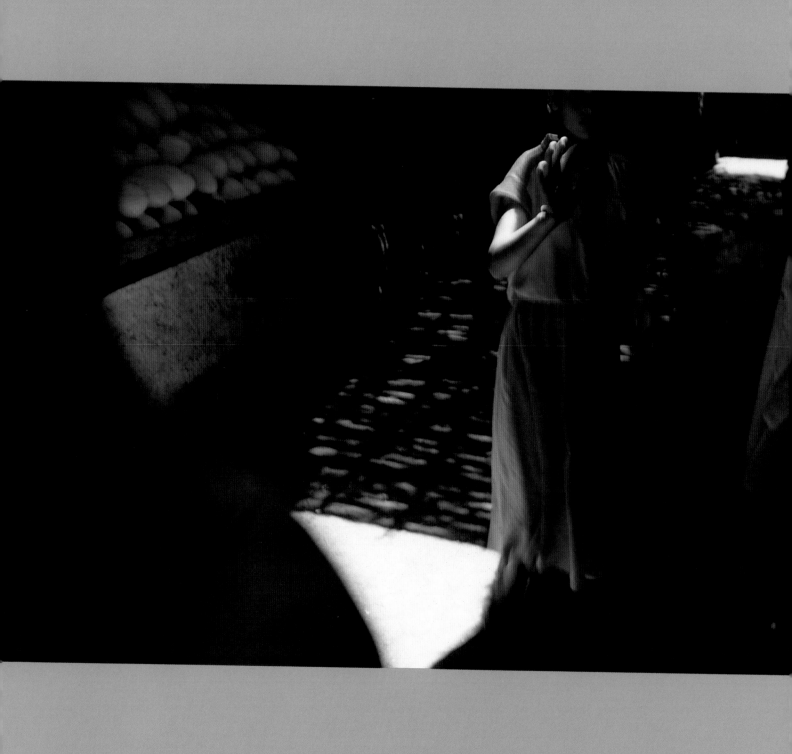

The Hakima
A Tragedy in Fez

William Betsch

With an Introduction by Paul Bowles

Secker & Warburg
London

First Photo Book Award
(City of Paris/Kodak–Pathe Foundation)

Contents

Introduction

By Paul Bowles

Fez is the place where nothing is direct. Going into the Medina is not like entering a city; it is more like becoming a participant in a situation whose meaning is withheld. There is a sense of deviousness and accompanying intrigue in the air, and the inhabitants do little to mitigate this impression. The enclosing ramparts were built high to protect the town-dwellers from the Berber enemy outside, and I remember that in 1931 the gates in the north wall were shut after sunset. The people were convinced that bands of robbers lurked outside, waiting to pounce on anyone who failed to get back inside through the gates before nightfall. They seemed, however, to be almost equally afraid of each other. I recall the difficulties involved in trying to walk through the Medina at night. Between one quarter and the next there were huge doors that were shut and bolted, to prevent those living on one side from getting into the neighboring section. It was necessary to find the watchman and persuade him to let me through. Then somewhat farther along I would come up against another such barrier.

Of all the entrance gates piercing the enclosing wall of the Medina, there is only one, Bab Fteuh, that permits the passage of a vehicle. The vehicle will have to be parked not far inside, there being no question of proceeding beyond the point where the street narrows into the footpath typical of the alleys of the city. The town was built for those going on foot and on the backs of animals. Fortunately, it has not yet been rebuilt to allow the passage of motorized traffic. As to the other gates, once inside them the only way to go is down. The topography of the place can be likened to that of a funnel. From Bab Bou Jeloud, the western doorway into the Medina, there are only two main alleys, the Talaa Kebira and the Zekak al Hajar. It's possible to find a few other very circuitous routes: unlike the two principal alleys lined with shops, these pass through residential quarters. But they all lead toward the maw of the city down below.

When I first walked in the alleys of Fez, I saw that the men were different from other Moroccans. Many of them were pallid, even sickly. I often had the impression that they aspired to invisibility, as if, not being certain of their identity, they would have preferred to slip unnoticed through the city. From their appearance I deduced, and I think correctly, that the Medina must be an unhealthy place in which to live.

The Ahal Fas are not loved by their countrymen. You hear that they are greedy, hypocritical, dishonest, treacherous, and abysmally vicious. There is no outrageous sexual behavior that has not been attributed to the people of Fez. If they are a quarter as evil as they are made out to

be by other Moroccans, then they must be very bad indeed. Happily it has not been my personal experience to find them so. But over the years the defamatory tales have managed to throw a faint pall of ambiguity over the town, so that notwithstanding what I knew, I sometimes found myself wondering how much truth, if any, there was in the legend supplied by non-Fassi Moroccans.

It seems clear that the unpopularity of the natives of Fez is due at least partially to their having been an urban population in contrast to the vast majority of other Moroccans, whose mentality was much closer to being a rustic one. The money of the country was concentrated here, as of course was the commerce. There is not much doubt that the original motivation for the widespread dislike of the city and its inhabitants was simply envy, although few Moroccans, even today, would agree.

Much of the pleasure I got from living in Fez in the early days had to do with being at one moment outside under the olive trees with the sheep, and at the next penetrating the ramparts. Because of repeated experiences which have not become permanent memories, I connect passing through certain gates with specific hours of the day. Bab Bou Jeloud is bright in the morning sun. The archway is tiled on one face in royal blue and on the other in emerald green. There are storks standing atop the minaret of the mosque directly ahead. The hot light of noon belongs to Bab Dekaken with its vista of the crowds filling the huge dusty enclosure of the Makina. Bab Segma I loved to go through just as the sun dropped below the flat Western horizon at my back. Perhaps because of the knowledge that as recently as the end of the First World War the top of the arch of Bab Mahrouk was often decorated with the severed heads of those who had expressed their opposition to the regime, dusk seemed the right hour to walk beneath its wide arch. And I associate Bab Guissa with rainy nights, when the faint sense of menace hanging over the city moved palpably closer, and although no less faint, became somehow more real. It was a fine sensation to slide downward into the city through the mud of the alleys, breathing the winelike odor of the olive presses, knowing that after uncounted turns to left and right I would emerge into the Souk Attarine, where there were a few lights and a few people standing under the dripping latticework overhead.

I know that now Fez has fallen upon evil days, and is no longer the same. The cultural and commercial capital is disintegrating. The people who might have held it together have left their great houses and moved to Casablanca, and the city now belongs to the very poor who, because of the desperate and violent tenor of their life, can only ensure its more rapid destruction.

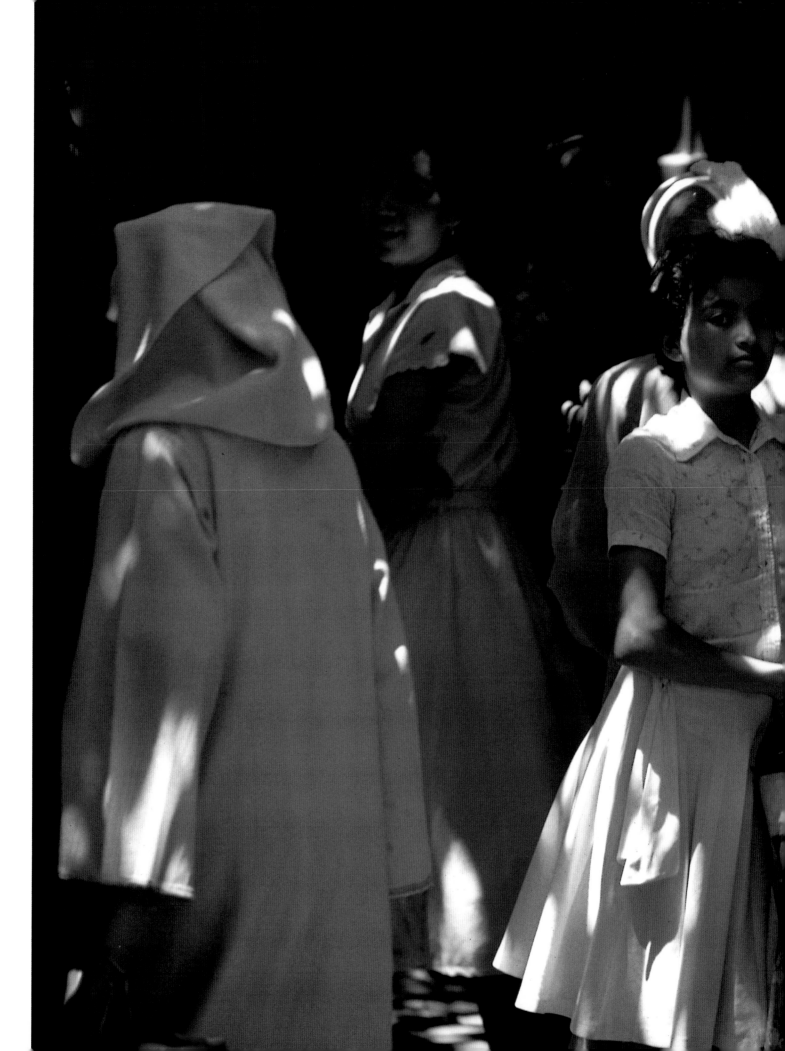

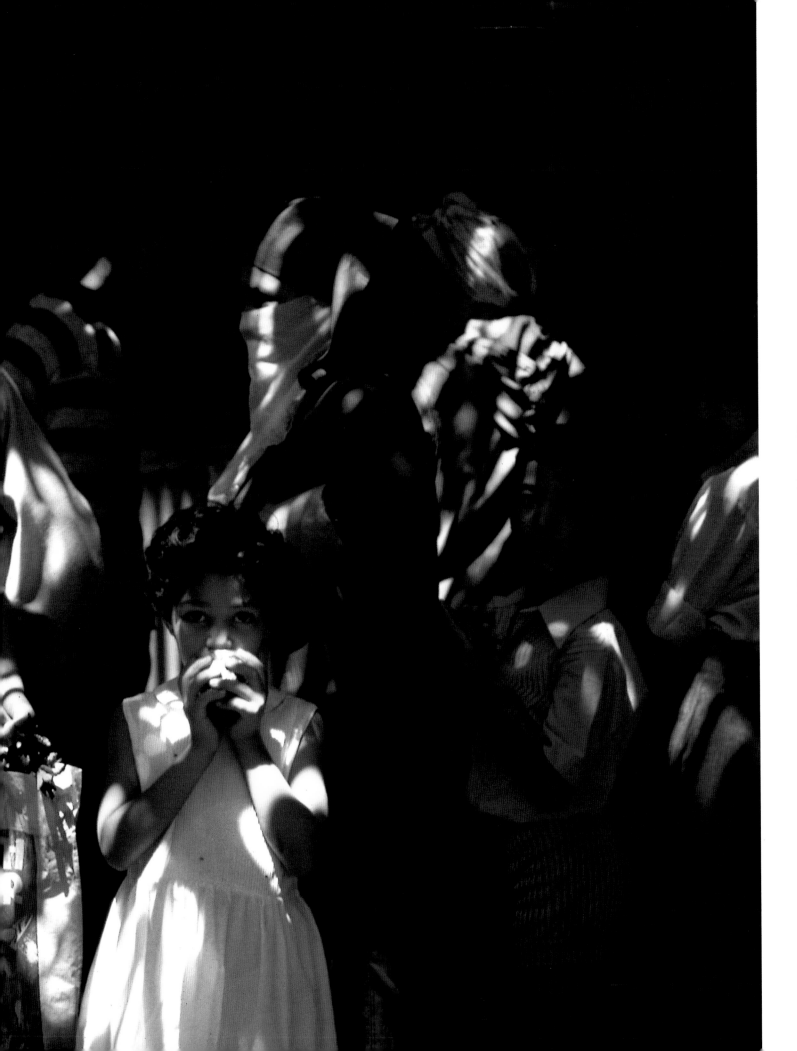

1. The Hakima

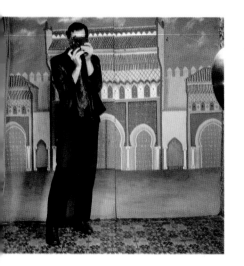

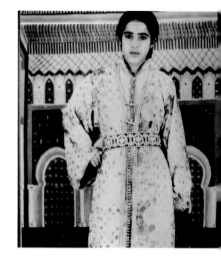

Once there was a land where, if it rained too much for the crops, a newly married couple—still considered bride and groom—would climb to the top of a hill near their village. Slipping off their underclothes, together they raised their *djellabas* above their heads. It was said that the whiteness of their exposed bodies shocked the dark clouds and brought back the sun.

Hakima ———— (her state identity card bears no family name) was born in Fez in 1962 (month and day unrecorded) and, as a bride of 16, took her own life on February 14, 1978, in a dispute over her virginity.

I chanced to meet Hakima once, a day when she accompanied her aunt who was the maid where I lived. I had no special feeling of any kind about her, and we hardly spoke. It is at first with difficulty that I even recall the occasion.

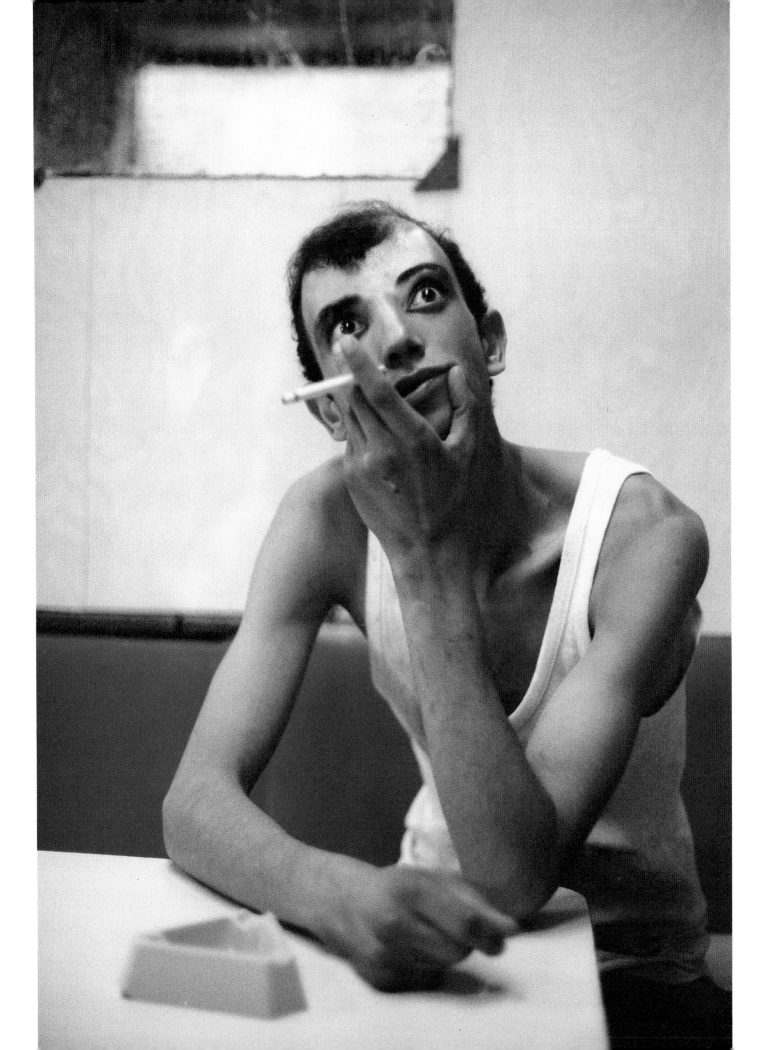

"Shame does not occur in a thing but to adorn it."
—*The Prophet*

ḤKM

ḥkim, ḥkima pl. ḥukâma *1. philosopher, sage. 2. magician. 3. (by appropriation) juggler.*

ḥekkem *v.t. to have to act as a judge, to set up as a judge.*

ḥkem, yekhem, yehkom *v.t. and v.i. 1. to govern, to rule. 2. to give orders to.*

-ḥkem f- *1. to order, to give an order to. 2. to dominate.*

-ḥkem'la *1. to judge, to pass judgment on (s.o.). 2. to sentence (s.o.). 3. to command, to have command over.*

-a.p. ḥakem *pl.* ḥokkam *1. judge. 2. commanding officer.*

ḥokm *1. v.n. of* ḥkem. *2. judgment, verdict.*

ḥekma *pl. -t,* ḥikam *1. maxim, proverb, wise saying. 2. wisdom. 3. magic.*

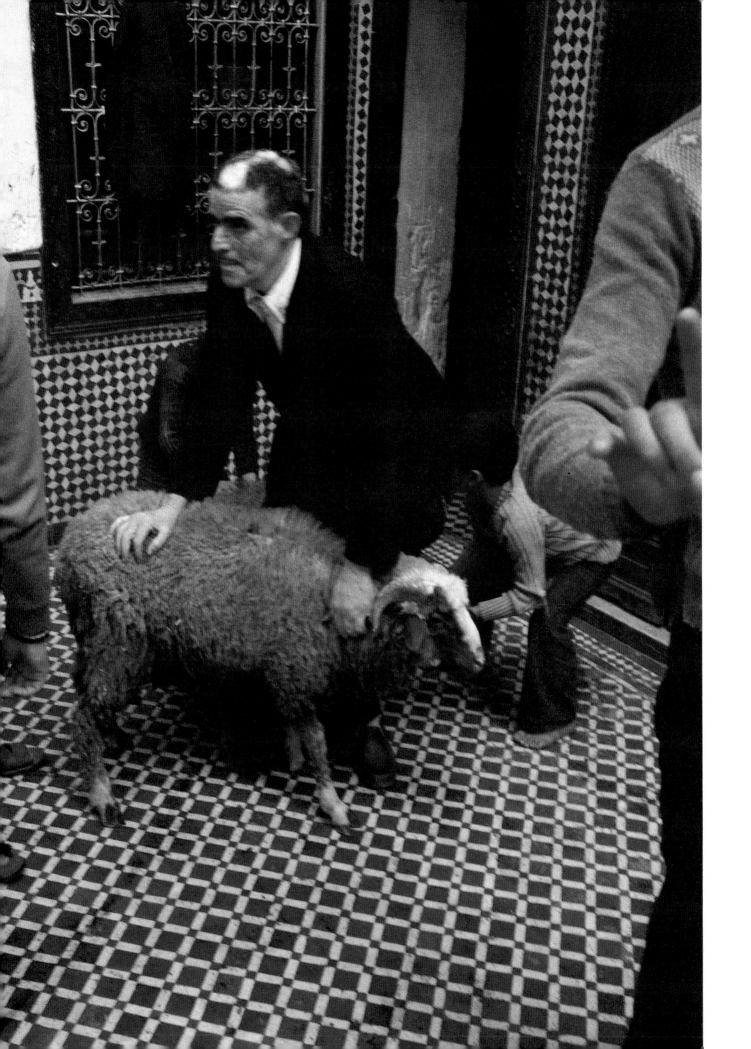

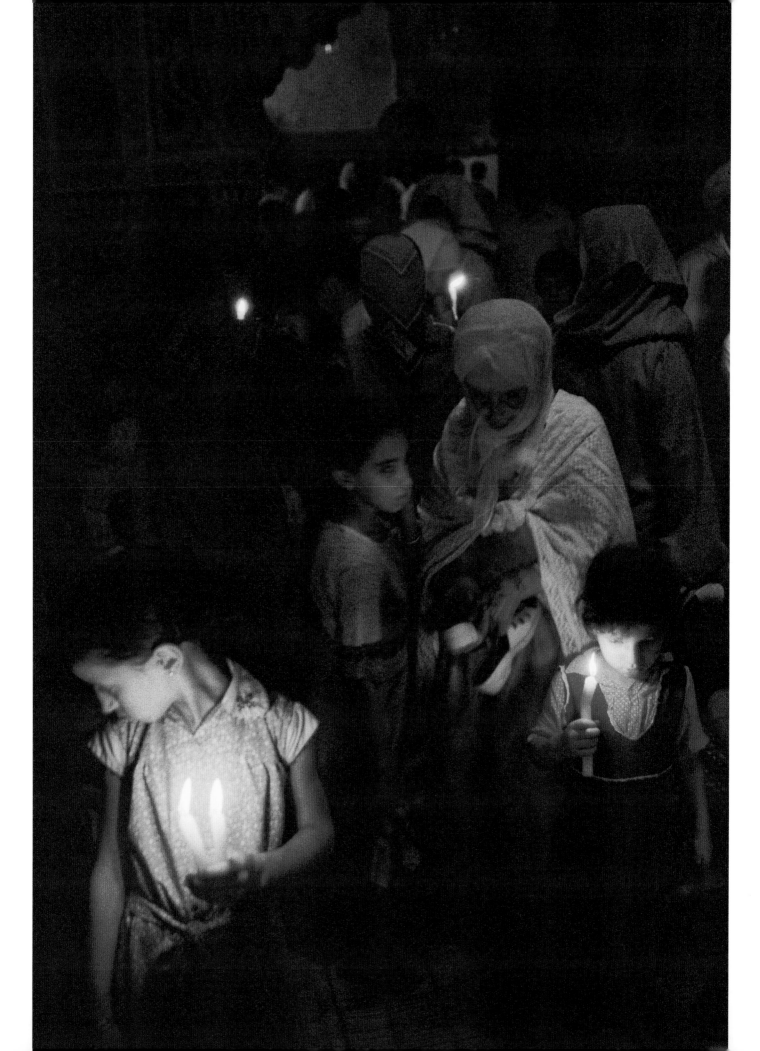

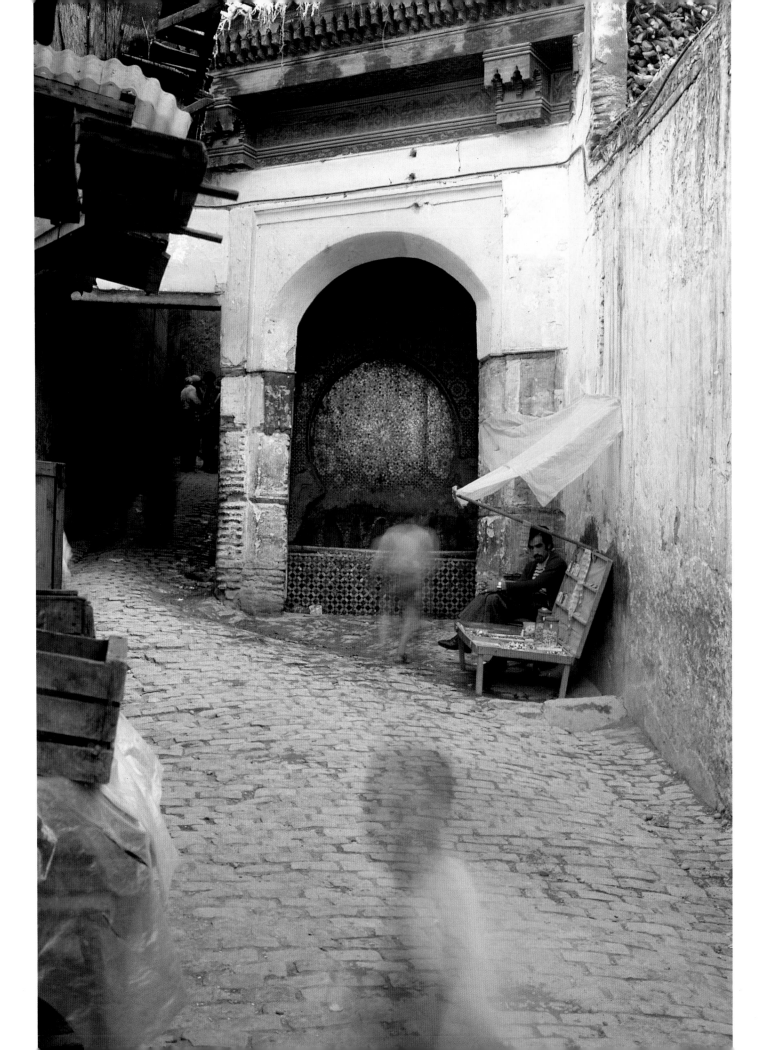

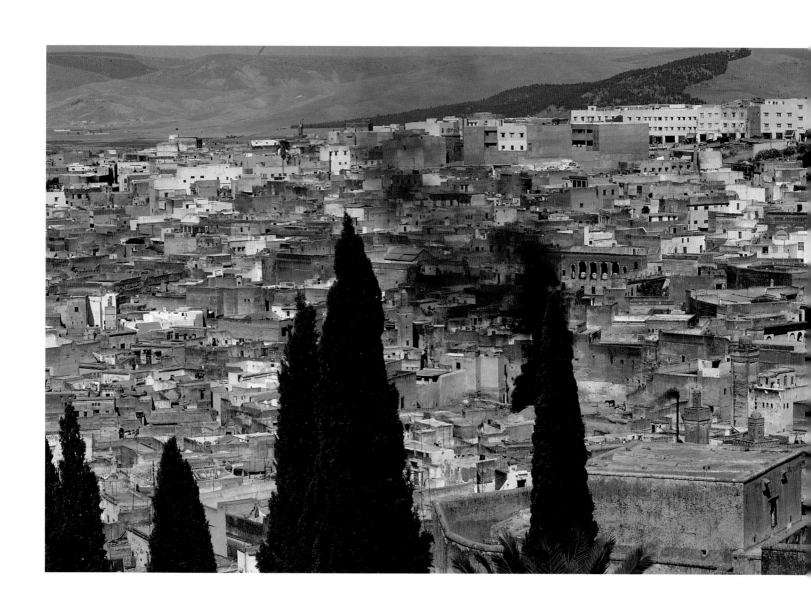

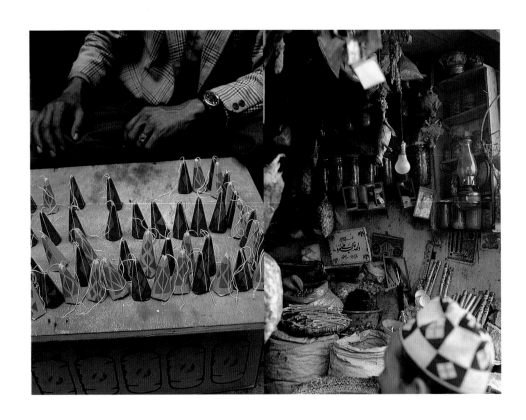

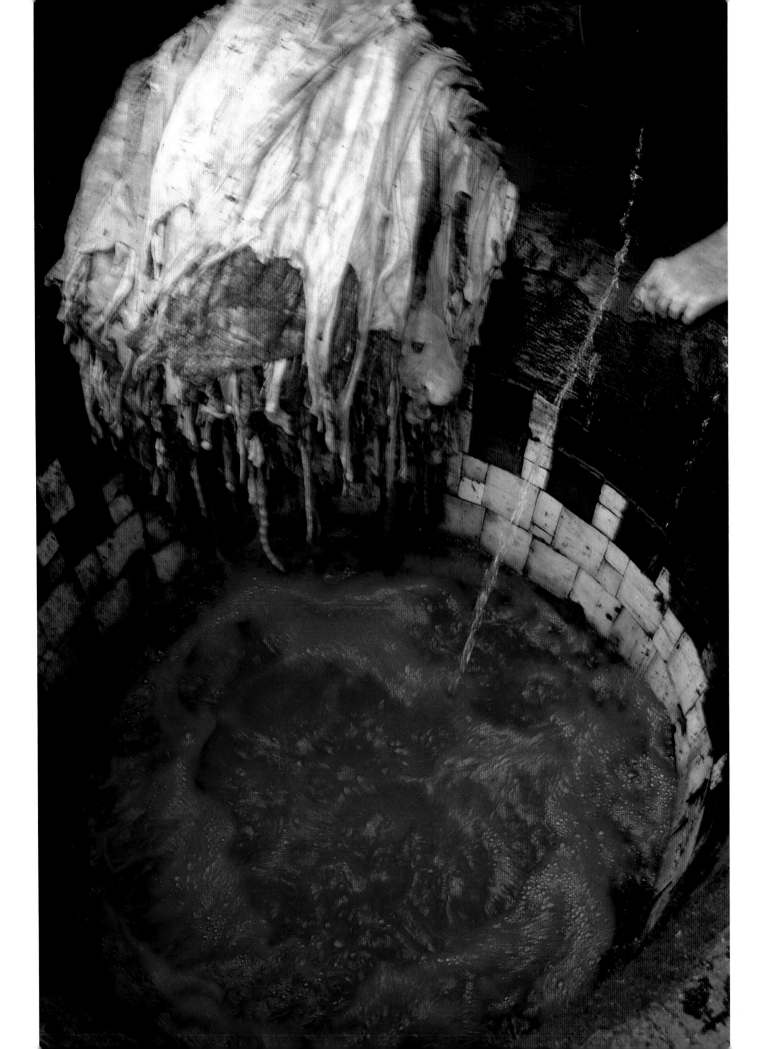

2. The Mountain

High on the flank of the mountain we step from the car. Below, the valley seems like a bowl filled with froth: the medina of Fez, each bubble not a house but a stagnant hour, centuries with all their moments rotting. Our guide, the Moroccan boy, Hamid, points to a *douar*, a walled cluster of mudbrick buildings, half-hidden by cactus on the hillside at our feet. We pick our way to the sorceress's door down a stubbly path, hardly noticing how dull the sky grows.

In a long room over the stable, C. sits crosslegged before the *shuwwafa* who squats, bathed in the window's pallor. The terrified guide, not allowed closer, coils by the door. With one hand back, he grips my knee as I crouch on the step outside: to see is forbidden. The still heat magnifies the smallest sounds.

Hamid hands a dirham to the *shuwwafa*. Her voice barks like a cock. She turns the coin between her thumb and forefinger, squinting at it. She takes three in all. The heat is unbearable. My shirt sticks to my flesh. The blood lumbers in my ears. The dank air smells of manure and has become very heavy. When the visit is over, I limp wildly down the narrow stairs, one leg pins and needles.

We ride back to the city in a tempest. The sudden rain clears the air and blots the road in the headlights into a blue and yellow mosaic on the windshield.

—The baby was taken away, in fact, by Naïma. She said, you can stay but I will not leave her with you. And Aiyachi remarked that also; he said, this is not a thing you can fool around with. You must not leave the baby alone. When the thing had gone beyond the limits of the room. Well, there was a certain tension in the house when we were there alone, as if we were always waiting for something. I was convinced it would go away of its own accord, but it was there the next night. Only the night. This time it was very persistent.

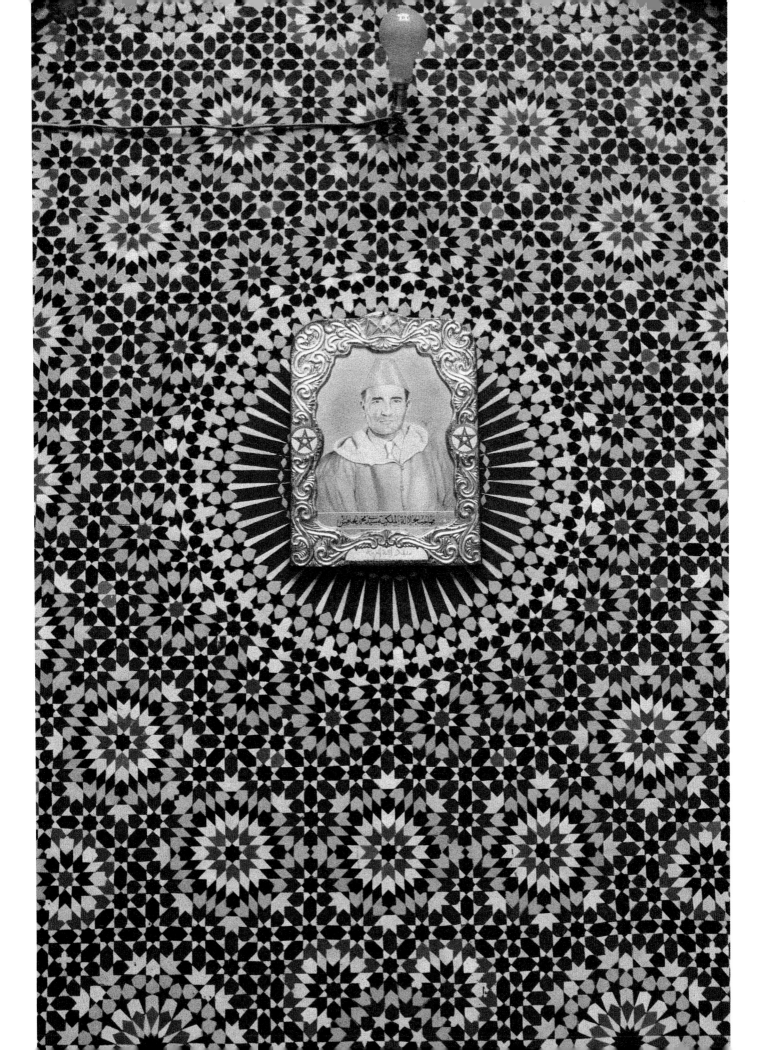

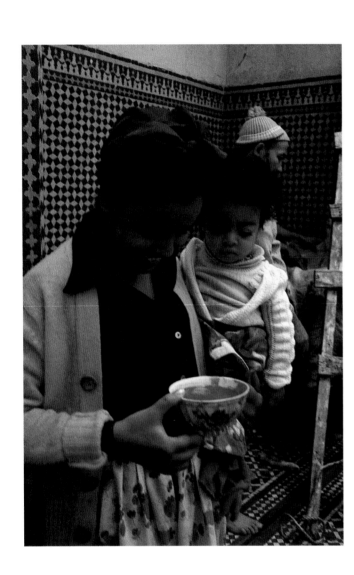

Still wet, Hamid searches the house. He rips his

image from two group snapshots as his mother scuf-

fles to snatch them. Tearing into fragments the pic-

tures of himself he has found, he heads toward the

bit-el-ma. "Everything into the *Oued*," he says over

his shoulder. When he returns, C. asks him what she

said. His look darts to me. "Do you have enemy here

at Fez, Bill?" He goggles his eyes with both hands,

meaning to photograph. "She says," he bares his

teeth, "he bites you." His theatrical gestures unleash

a gale of laughter.

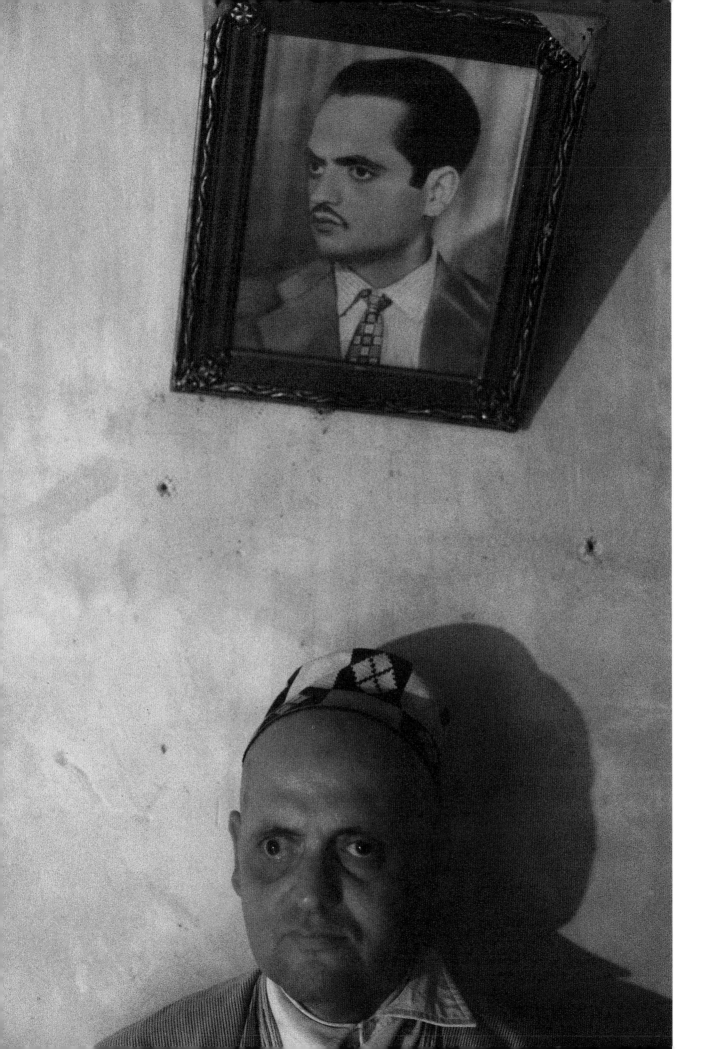

—And someone said something to someone else and—

finally we were pushed, pushed toward that window

and, and suddenly the curtain was drawn, and we were

pushed and elbowed even closer till our noses were

pressed to the glass. (*Pause.*) It took a second or two for

my eyes to become accustomed to the light and the

forms in the room (*indecipherable*) or where to look.

Near dawn I wake, realizing my eyes are already open, fixing the shadowy corner. I am lying on my side, arms crossed on my chest, hands near my shoulders. In one hand, I hold a hammer with a tapered metal head, in the other a long, wooden handle—a shovel? an axe? Its end is concealed under the bedcovers, and I cannot move even my eyes. The hammer handle is polished with use and ends in a kind of bulb. More than my own immobility, this detail chills me, binding me to a certainty in time, more than to the object itself. I try to release just one finger, but my body does not respond to my thought. I try to will my looking closer to my face from inside, like swimming, wriggling through water with hands tied. Useless. I am frozen in a glass sarcophagus of myself. The shock of this irreversibility, as if "in the blink of an eye," though that is impossible, brings a change—the tools disappear; my hands grip oval spaces. Immediately relieved, I still fear the corner and roll toward C.'s sleeping form. I press my hand against her back to anchor in the rhythm of her sleep, but everything is worse. Before me is a curtain of palpitating pink and yellow, like a flat cloud of swirling, luminous sand or snow. Stiffening instinctively against an imminent fall into it, I suddenly fall asleep.

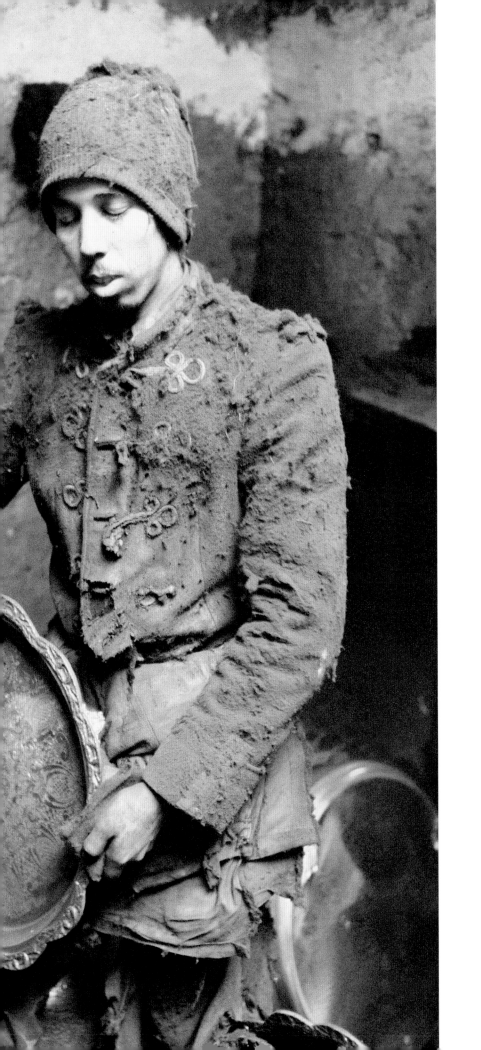

I do not mention it to her, even after I remember where I had been and why, still asleep, I had been staring: in a park at the end of day a woman walks ahead of me, eluding me despite her heavy limp. She wavers as if drunk or in a trance and does not see the thugs with clubs who shadow us. Unable to close the distance, I try urgently to call her, but only a single syllable surfaces: "Ma!" The nearest one swings his stick in an arc, striking through her head, spraying red fragments everywhere. The image fades to black, followed by houselights. C. and I are sitting in the first row, which explains why the image seemed to surround us. She takes my arm. "Let's stay for the beginning."

ma *(n.) pl.* myah *1.* water. *2.* juice. *3.* sap.

ma *used to express amazement or admiration:* ḷḷah 'la had-l-bent ma zinha! *God, she's a beautiful girl!*

ma *particle of negation:* hiya ma-ši mezyana! *She's not pretty!*

ma *used in interrogative expressions with the preposition l—:* ma-lek? *What's the matter with you?*

ma *1.* used as a kind of relative pronoun: ma-'andi ma nqul. *I have nothing to say (—What can I do? I'm caught).*

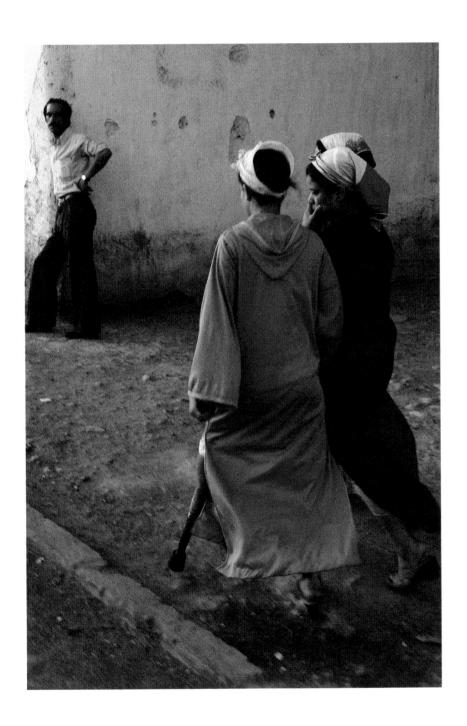

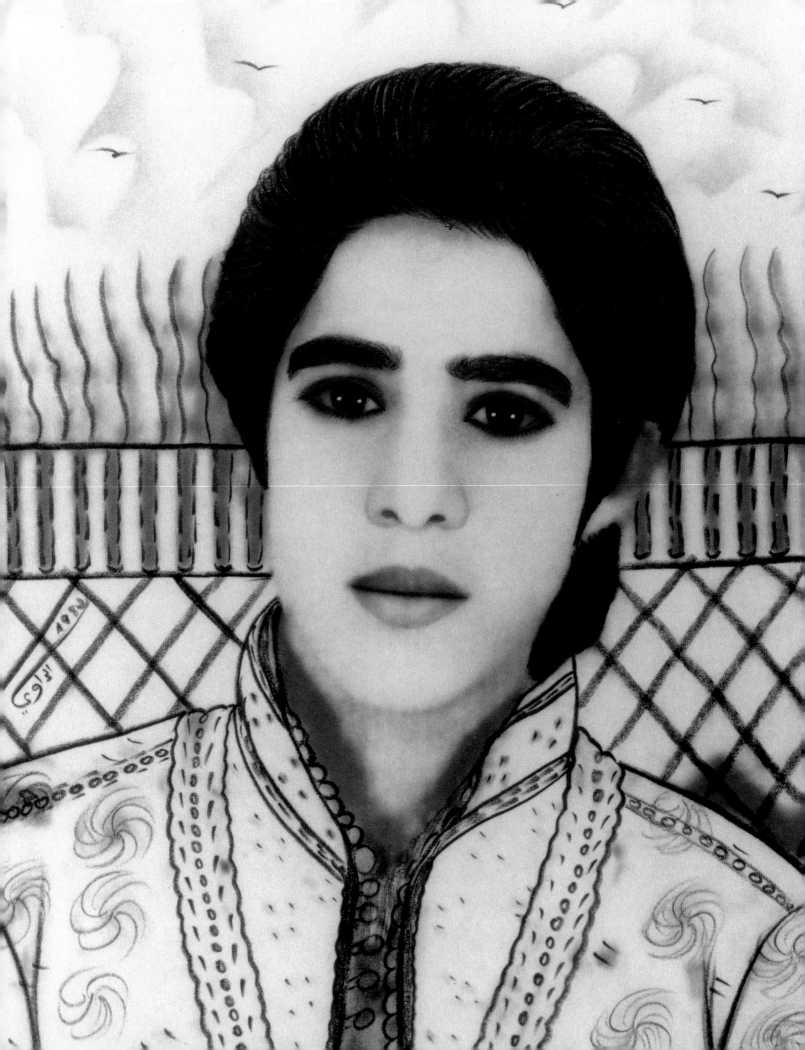

"There was no relation between us yet. No problem. Moreover, I closed my eyes to the things I saw. In addition, my sister was telling me that I shouldn't marry anyone but Hakima. So, I accepted. The fact she threw herself from the balcony, I know nothing. All I understood was that her mother threatened her. With the knife in her hand she said to her, it's you or me. *Before* the arrival of my sister. Isn't that the story we were told, Fatiha?"

"That's what we were told, in any case. We weren't there."

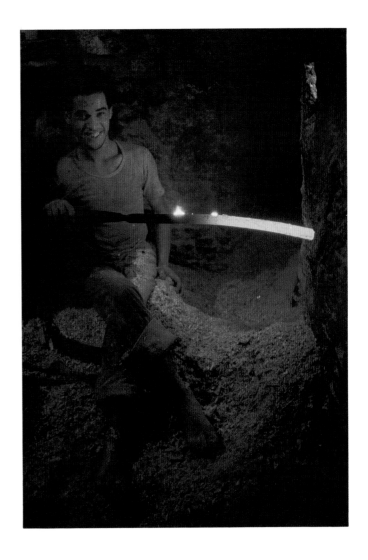

W.—Sometimes not strictly a rape.
C.—But this cassette—
W.—Yes. There he says, "*dkhal aliha*": "Maybe it was he who entered into her chamber." That is, he did it with her complicity. (*Pause.*) The other word is *taâda aliha*: "he passed upon her" . . . What's the matter?
C.—Nothing.
W.—But what are you thinking?
C.—Nothing.

In her diary that day C. describes a dream:

"W. and I are climbing a sloping street whose paving stones are iced. We are on our way to a furniture storehouse, or is it a library? A gust of dry hail stings our faces. The street reminds me of the twisted main street of Gdansk. We arrive at the crossing whose roads lead to our goal, but a row of thugs linked arm in arm bars the way. We must renounce one after the other our planned destinations and turn back. The hail striking our faces is stimulating rather than menacing, and I do not feel disappointed by the difficulty. On our right we find the entrance to a cinema which evokes for me the *Kino Realta* before which I stopped in a mining town in Silesia in August. Its facade shines, vibrates, pink, entirely covered with spangles brilliant like neon. If that's where we are going, I say to him, it's not important to have missed the other route. I feel his hand grasp me from behind, the way one takes a book by its spine. With a sensation of relief, joy, and recognition, in his company I penetrate the cinema while the hail storm changes into a sandstorm: Egypt."

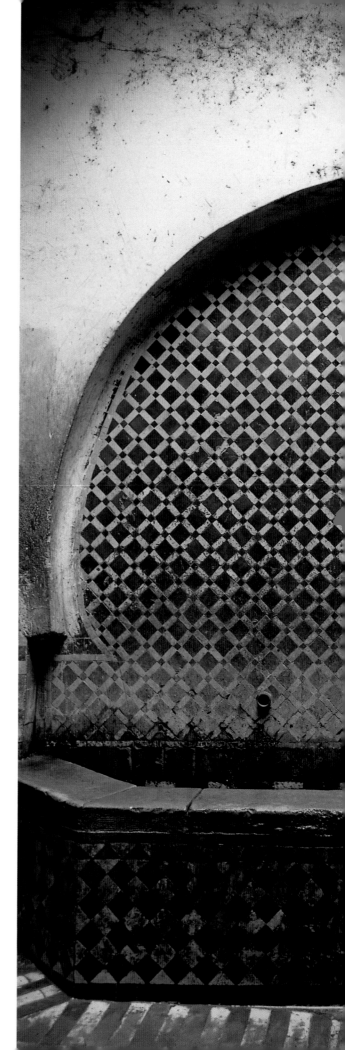

'ăyn *(f.) pl.* 'yun *(dim.* 'wina*) 1. eye (person, animal, needle). 2. evil eye. 3. spring (water). 4. same:* ẑbertha f-'ăyn l-makan, *I found her in the same place.*

-f-'ăyn l-mut, *at the point of death.*

-n'ăs 'la 'ăyn qfatu, *to sleep on one's back.*

-f-seda 'ăyn l-bent, *to blind her (deflower a virgin).*

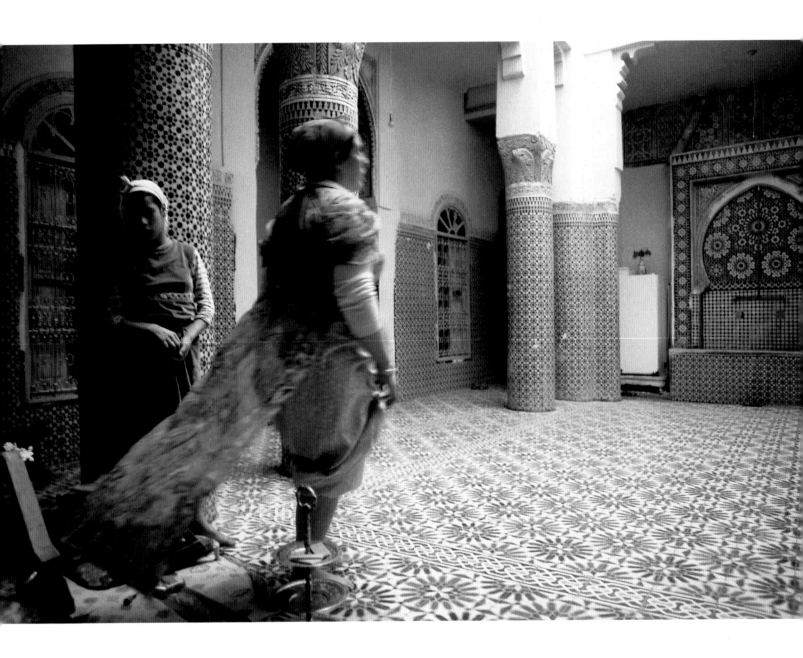

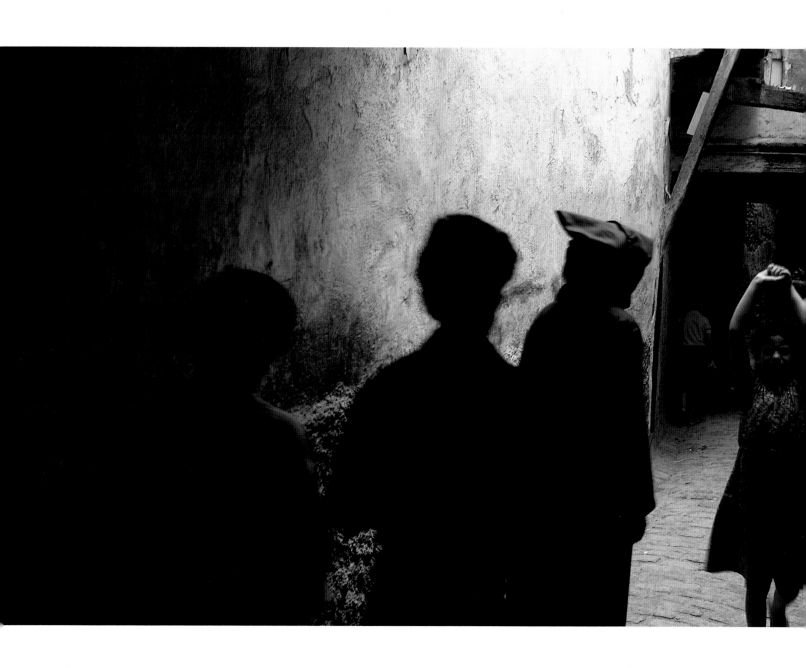

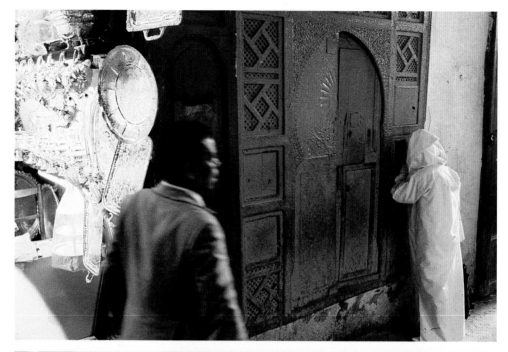

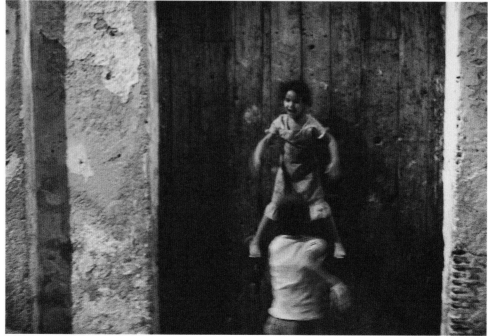

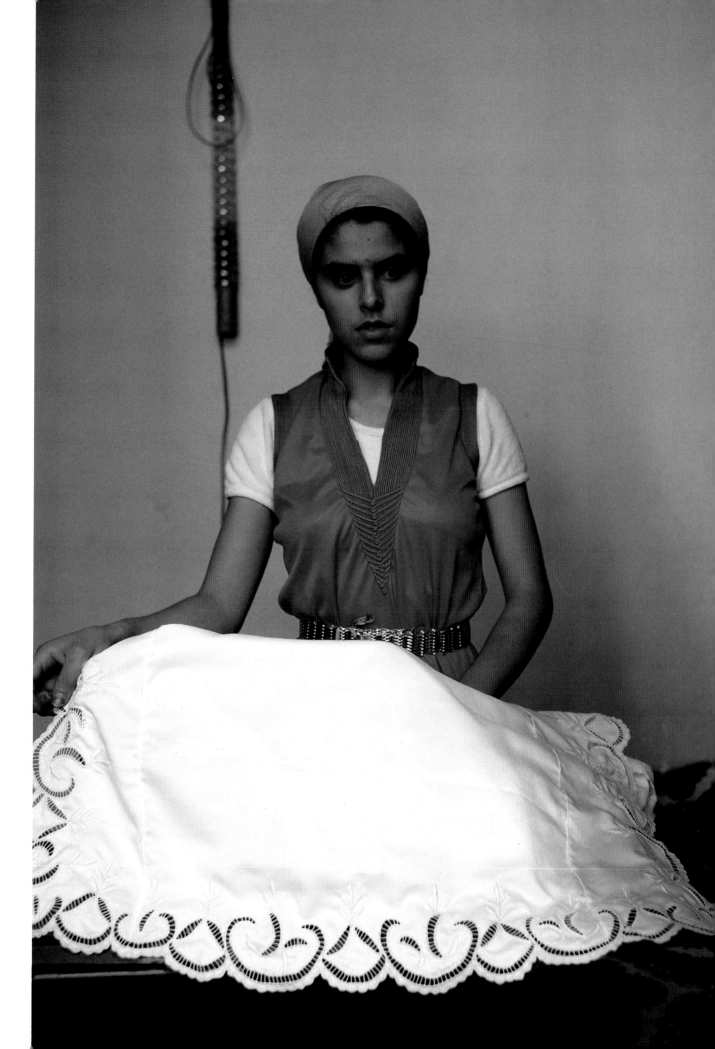

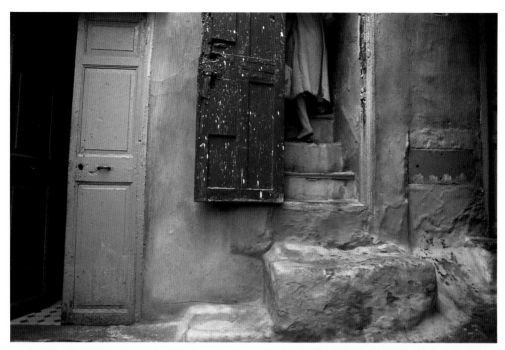

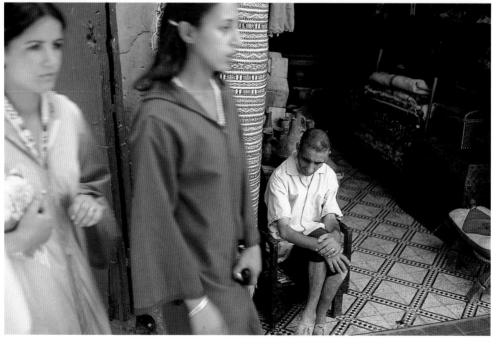

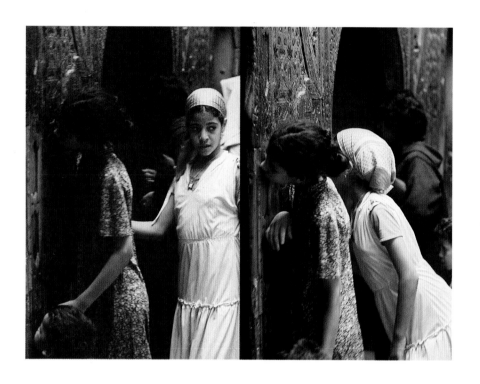

3. The Recipe

On the eve of the wedding, the bride's mother draws blood from between her daughter's eyes, the tip of her nose, the tip of her tongue, her right shoulder, elbow, hip and knee, and her vulva, eight wounds, using a dart-like knife and a bit of cotton wool which the bride puts in water with a few dates. When her husband returns for their second night together, she feeds him the dates to bind his heart.

—The only thing I remember is that—Abdulkader—this is the fiancé? I don't even remember his name. But that Fatima had told me that—some years before when he had been, I don't know, 15 or 16—he had come to Fatima and said, "Please save Hakima for me. I want to marry her." I always remember that, because she seemed so pleased that, y'know, he felt destined to marry her, and was waiting for her to—come of age.

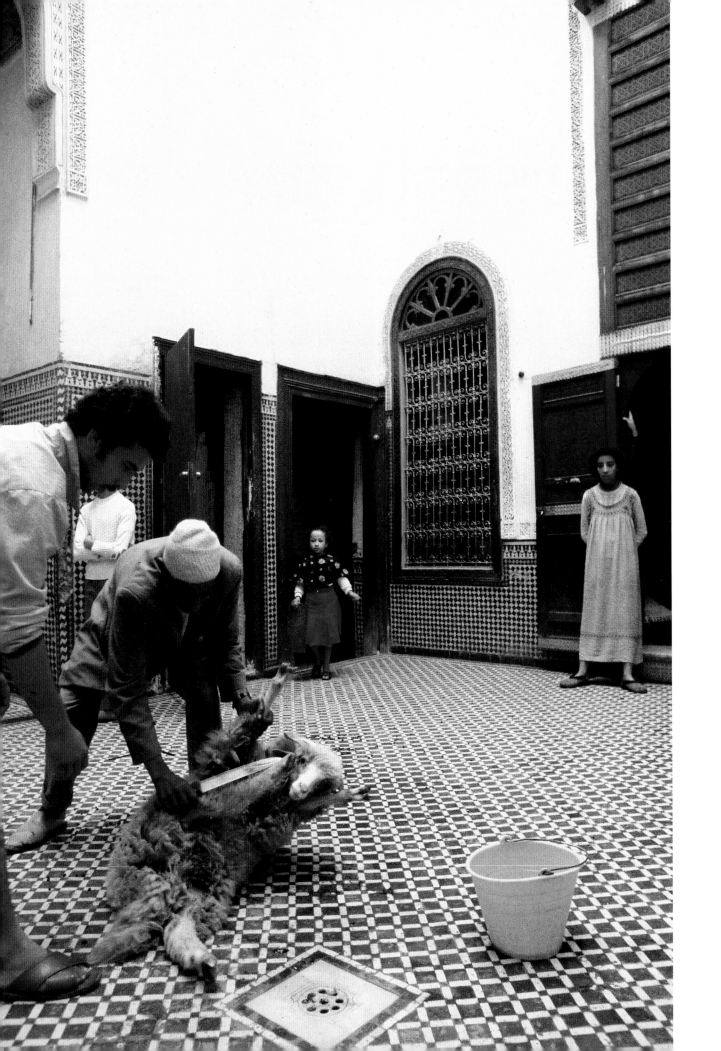

"When they told me she'd thrown herself, me, I was shaken, like a fiancé, if you like. It was far from love. So, I began to look for the cause. She was at the *bain maure* with her mother. They came home. Her mother began to tell her, why do you go out now that you have your marriage contract?"

"They stopped for coffee at the house of his sister, Hazira," his wife interjects.

"No, no."

"Yes." She returns his glance.

"Yes, there was something like that. Yes, excuse me. There was that story, but I forgot to mention it. And there was a misunderstanding. My sister told her if she wanted to start going out like that, like she wasn't married, 'It's better I tell my brother to renounce this marriage. We asked for you in marriage and chose you so that you'd stay home till your wedding. Not spend the day in the street with your friends. No way.' Maybe she loved someone else. That's what I heard. I didn't see anything, however. Maybe it was he that 'entered her room.' Perhaps. We're not sure."

"He asked for her hand. It was she who wanted the marriage. Me, I didn't want her to marry. When they came, the policeman and his wife, there were the *Isawa* in the street, the brotherhood, the musicians. I'd come home from work and we'd gone to the bath, Hakima and me. We hadn't even yet had a coffee to cool off from the bath. Hakima still had a towel on her head. They knocked on the door. Them, they're the kind who have no shame. They wash their face in the chamber pot. She told me, so you've seen Hakima? We know she's a good girl, but she does those things *exprès*. If she has somebody else in mind, she should say."

"But nobody pushed her."

"The little maid, the little servant of his brother-in-law, the policeman, had told them she was at the window and had spoken with a man, with one of the salesmen in the boutiques across the street. I said, the girl belongs to this street, she grew up here. Everybody knows her. Even the salesman across the street. And if she wants to talk to him, who can stop her? But Hakima said she spoke to no one. Except that, there were people passing, the *Isawa*, that it was the birthday of the Prophet, the *Mulud*."

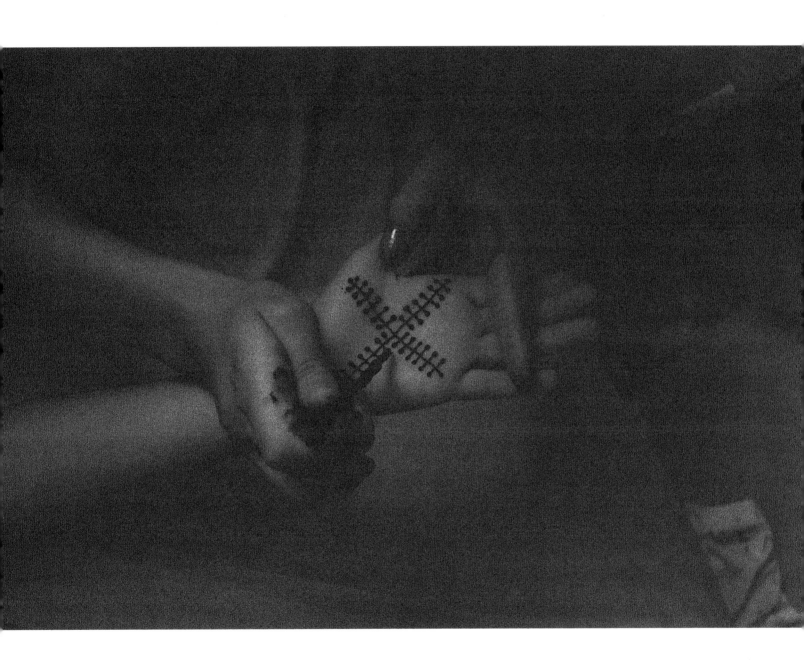

"I told them, Hakima, Hakima, I'm not going to shut her in the closet and throw away the key. She said no, we made the contract, we're taking her home with us right now. Until my brother decides to take her. I said, but let her finish her trousseau. The wedding's not very far. But it was 'no.' So I said, why do you do that, my girl? She said the little servant lied. That she'd seen her speak to another girl from the balcony. She said, 'Mother, she saw me laugh with my girlfriend; what's more, I only smiled. Another girl made a sign to me from below and I replied.' With that I got furious and began to hit her. I hit her and I caught her like that and I hit her. I told her: 'Today it's your end or mine, because it's you that wants slavery. You who wants to be colonized.' She screamed. The policeman, the husband of the sister-in-law—the policeman, the girl was very strong and he caught her with me. Maybe she wanted to throw herself then. We caught her, we took her and made her sit down."

"Didn't they want a medical certificate proving her virginity?"

"No, there was no question. The doctor's paper I had made and I gave it to them when I gave the girl in marriage. All that happened was that I hit her. I caught her in this corner and I hit her. She went there, in the other corner. So I caught her. So he came, the policeman, to hold her with me, him, he held her by the hands, the policeman, him, he made her sit, here, on this banquette."

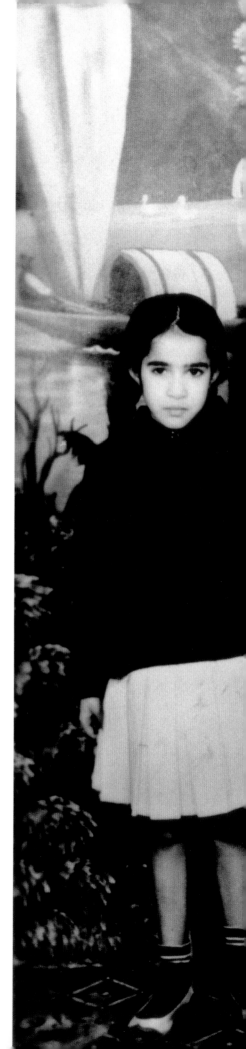

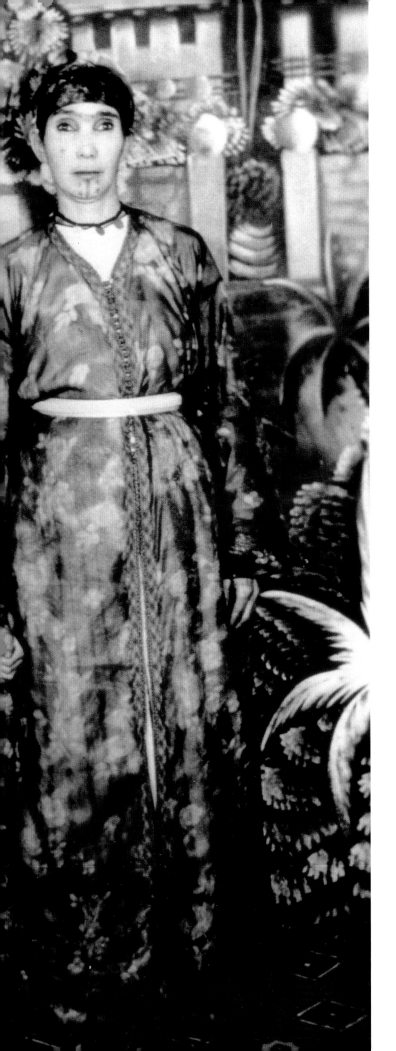

—I was sitting in the salon, the one we called the "Mo-roccan Room," or the "Mirror Room." I had put on some music and was reading a book, half-reading and half-listening to the music. And between these two perceptions came a third *(breathes slowly, heavily)*. Exactly like that *(breathes deeply, exhales)*. Very rhythmic and very regular. Like someone sleeping.

"We talked, we quarreled, them and me. I'd stopped hitting her. I said, there's nothing between us. We don't need any marriage. What you've brought is still here. The gold bracelet, here. I took it off her hand, with the ring. Here are your things. Finish. The end. Leave us here and go break your head, if you like. And that was the problem. 'Leave us here and go throw yourself' . . . She said she was going to get some water. It didn't occur to me she was really going to throw herself. She said, 'Me, I'm going to get some water for whoever is thirsty.' I trusted her. Then I heard a *pom!* She was downstairs, in the courtyard. At nine-thirty. In the evening. The photographer was not there."

—Up till then, I had no fear at all. I was just curious. So I went to the corner of the room. And when I got there, I realized that, ah no, it wasn't coming from that corner, it was coming from the other corner. Or not exactly from the corner, from the bottom of the wall. Well, I got down near the bottom of the wall. Putting my ear against the baseboard. All of a sudden I realize that, well, that it was coming from the *other* side of the room.

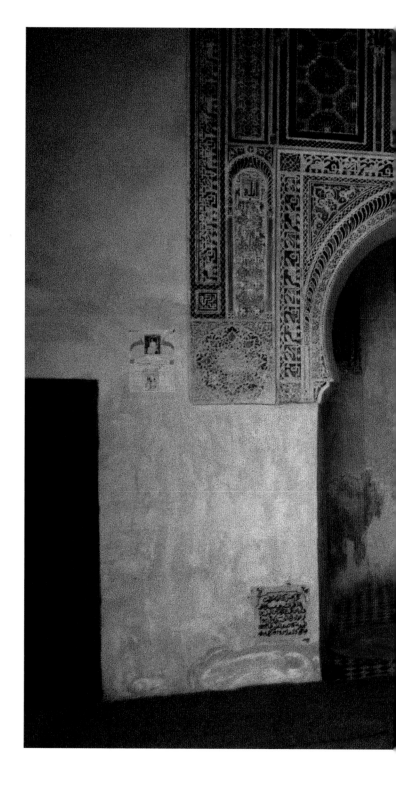

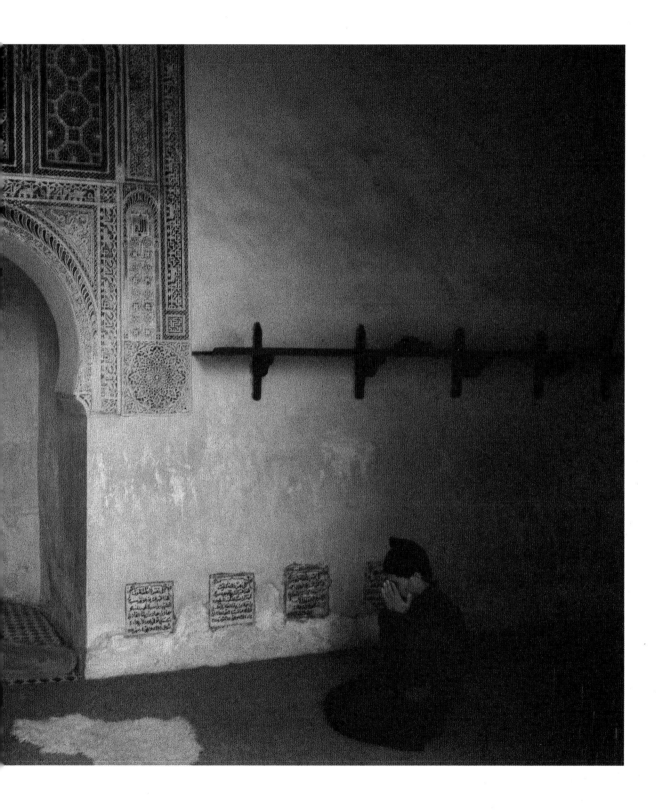

"I heard the fall but I never thought it was her. The neighbor called me, *Mère* Fatima, get up, Hakima's fallen. I told her, if she wants to fall, let her fall. I thought she had fallen in the corridor, that she had an attack of *riyaa*—that she was possessed. So we all went down. Hakima was on the ground. (*Almost inaudible*:) Like that. We found her on her right side. She hadn't made a sound. (*Pause; a male voice sings the letter â through several registers.*) So they go down, they bring her up. (*Either* bleeding *or* making sounds; *the tape is not clear.*) The policeman and his wife brought her up. So, me, I, it, it, finish; the blood was coming out of her mouth. (*She claps her hands once.*) And him, he took his hands and put them here (*she crosses her arms on her chest*). And that was that; the blood came out of her mouth. He took her, he pushed, like that, on her breast. I was in heaven and on earth. I didn't know any more what was happening. And that's all. Everything had turned into tears. The morning—"

"The policeman pushed on her chest, right? And it's like that she—she hemorrhaged internally."

"Yes."

"And he made her bleed, which was—"

"*Ah, nam, nam, nam, nam.* Yes, yes, yes. The policeman was here, just here."

—But Fatima said she gave you the medical certificate proving the girl was a virgin.
—No, no. (*Turning to her mother*) Did she give us any such paper?
—(*The old lady*): No.
—The bitch. Did she give us such a paper?
—(*Sliman*): No, no. Her paper was given in the operating room. She was not a virgin.
—When she was brought in, she had the medical certificate at the foot of the stretcher. They always have that. Because there are girls who are raped while they're in the operating room. When a person is unconscious, they risk getting raped. It was written she was a woman. My husband said, but no, she is a virgin, my brother-in-law has just gotten engaged to her. But the orderly said, no, she's a woman.

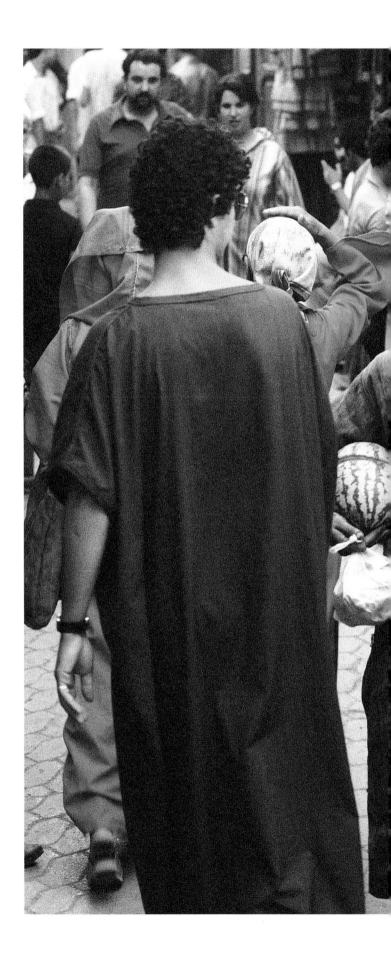

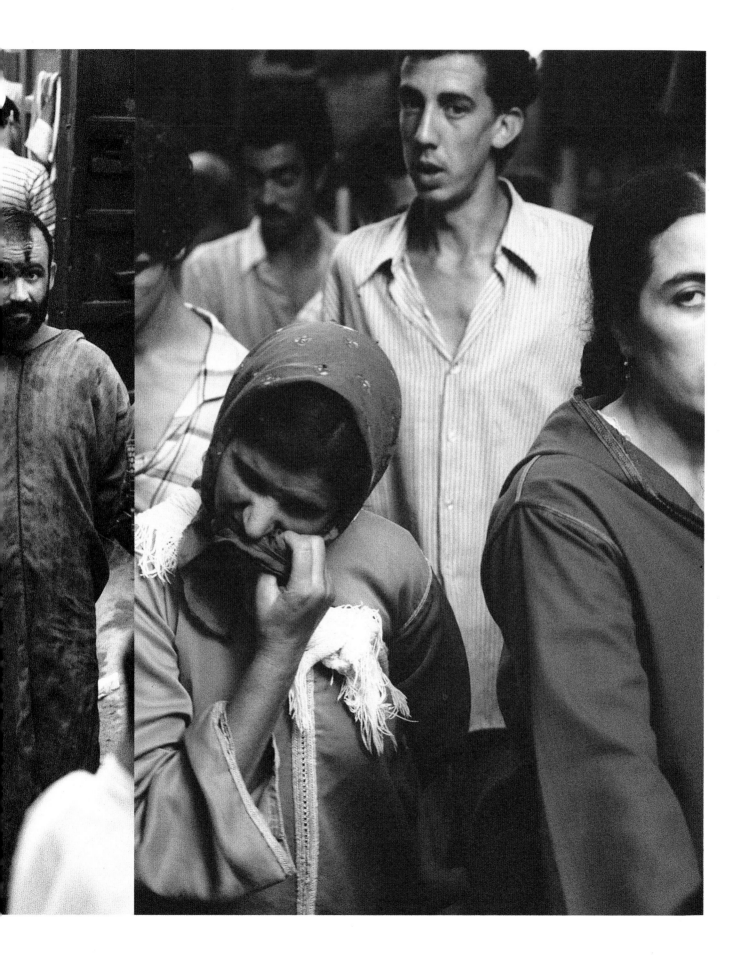

"But we heard that your family had demanded a certificate of virginity."

"Exactly. The very day—ah, I see. Now I remember. Why did my sister come to see them that day? She said that since she'd seen Hakima laugh in the street with a man, she said we had to have a certificate of virginity. Because she couldn't trust her anymore. So we'd know what we'd bought. Once we had the certificate in hand, we'd celebrate the marriage in a week—or else we'd stop everything. We'll know whether the girl is still valid or not."

—It's my husband who brought her back up. (*Pause*) It wasn't my husband who was the first to bring her. It was a watchmaker. The one who had the shop downstairs. It's him who brought her. It's my husband who took care of her. He brought her to the hospital, he fed her, he buried her. For two weeks he couldn't go to work. Two weeks he cried for her. They even took his gun away, they were afraid he'd kill himself. And it's him who took care of everything.

—It's her who killed her daughter. She knew. There was

a woman who'd gone to see her, saying her girl wasn't

valid. The girl refused to be examined. The mother had

a knife in her hand, she told her, I'm going to kill you.

She went to my husband. He said, why do you want to

drag her to a doctor? We took the girl like she is, we

accept her with all her defects. The next day she threw

herself. People came to tell me she had killed herself.

—I thought you were there.

—No, no. People came knocking on our door. When we

arrived the mother didn't want to open. My husband

asked the neighbors what had happened. They said, *la

Háiyan* is going to cut her daughter's throat. He beat on

the door till it fell. We found her with the knife drawn on

the girl.

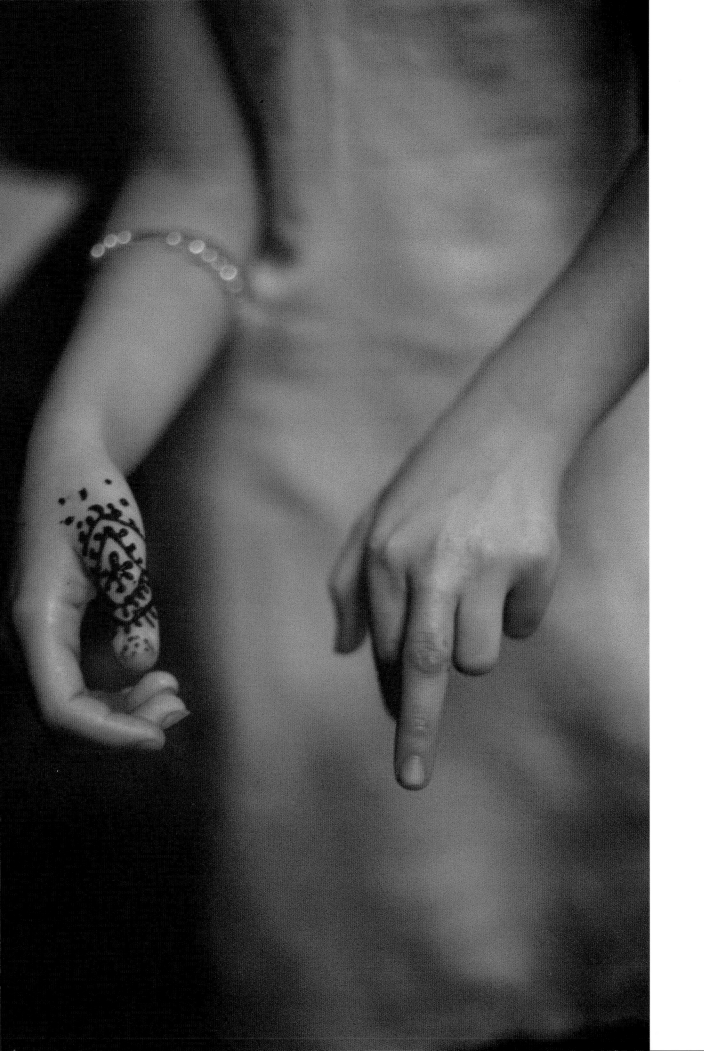

"The ambulance came right away. They measured, they asked what had happened, how it had happened, if anyone had pushed her. She fell by herself. Her clogs, she left them at the edge of the balcony."

"But she shouldn't have been moved at all."

"Nobody touched her, it was only I who touched her . . . So, my God. Like that. Leave me all that. Me, if I'd had my sense, I wouldn't have hit her. Wednesday morning I went to see her in the hospital. Friday she was dead. She was in a coma. We couldn't enter her room. That's it, the reason." (*Claps her hands once.*)

—Animal under the house was the first idea: I can remember some flashes of, uh, "they're playing tricks on me, the Moroccans, they've hooked up a hose with a little pump," y'know, or something like that. But it didn't really bother me. At one point, Ba Mohammed came and we went and heard it. We went outside with a light. In fact we found a hole in the garden that would seem to—lead into a tunnel, underneath this very room. We couldn't quite come up with an animal but it must be, you know, something like a mole or—

—How big was the hole?

—Big enough, it was about, what would I say, about the size of a skunk hole.

—Like, you could put your arm down it.

—Yeah, about like that. And the women left the next day.

—You know that Fatima stayed a month at our house, in

your old room, she almost never went out. And then she

left for the mountains. That happened in the springtime.

Later, I returned to her former address. There was an-

other woman there, but I didn't understand what she

told me . . . Oh, there was a frightful scene at the hospi-

tal. The girl died in the hospital, she had a cranial frac-

ture. She also had another wound, internal, I believe. I

think that G_____ also went to see her in the hospital.

He'd certainly know more than I. He went with Fatima to

the hospital.

Sometimes, despite all precautions, a witch cun-
ningly slips a finger into the vagina of the bride's
mare during the procession in the street; that night,
on the evidence of her ultimate "wound," the bride
is found not to be a virgin. Then the bridegroom's
family cries, "Take away from me your bitch," and
her father or her brother shoots her dead on the
spot in the bridal chamber or before the guests in
the courtyard, and all the money and gifts are re-
turned.

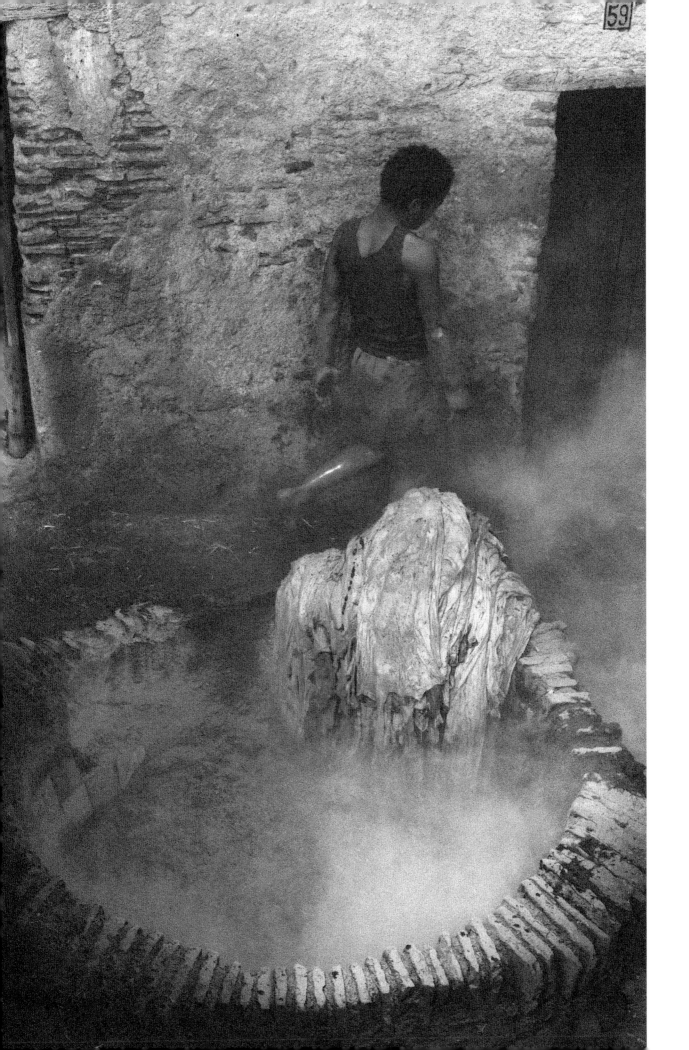

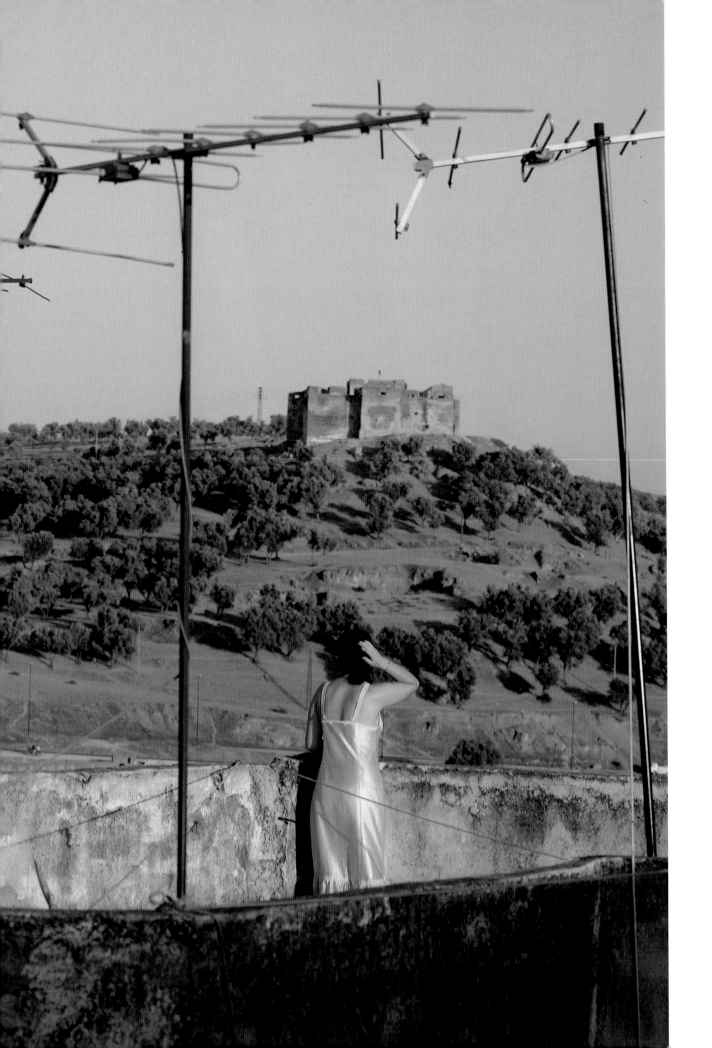

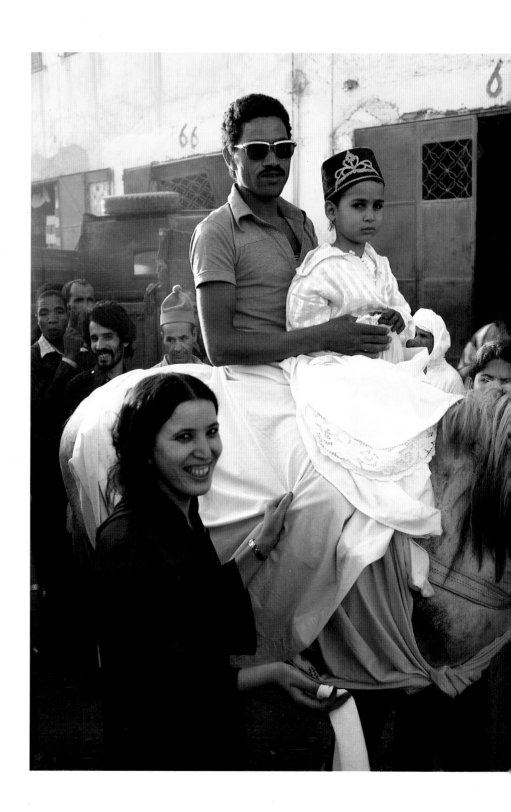

4. The Souvenir

They found me in the snow. I lay for several days and nights unconscious in a fever, an unwaking, single sleepless night in which I passed easily from one world to another, floating in a turning well of red

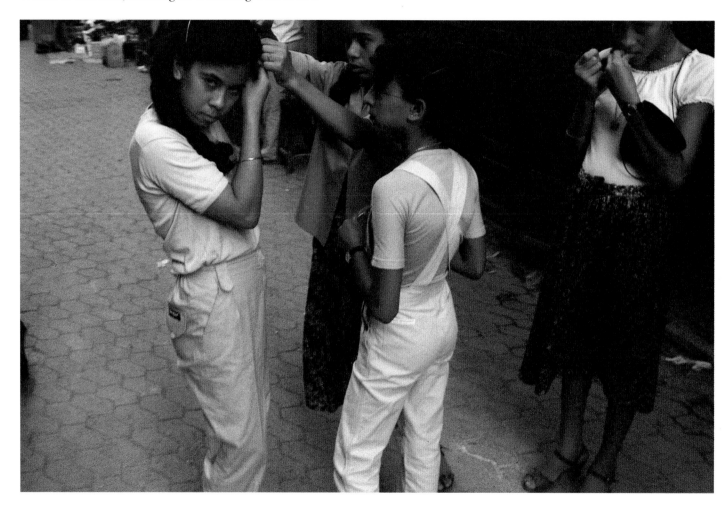

and black. Frequently an enormous, dark globe materialized: a satanic face with three piercing, yellow eyes, one a diamond laughing in its forehead. No sooner was I aware of it than a tremor seized its features, and another, and again, as a lubricious, red ram roared out of the cavern of its mouth, a train of phantoms which struck me down, grinding me to pieces, and bouncing back as if I were but the ball bound to the bat in an infernal game of jokary.

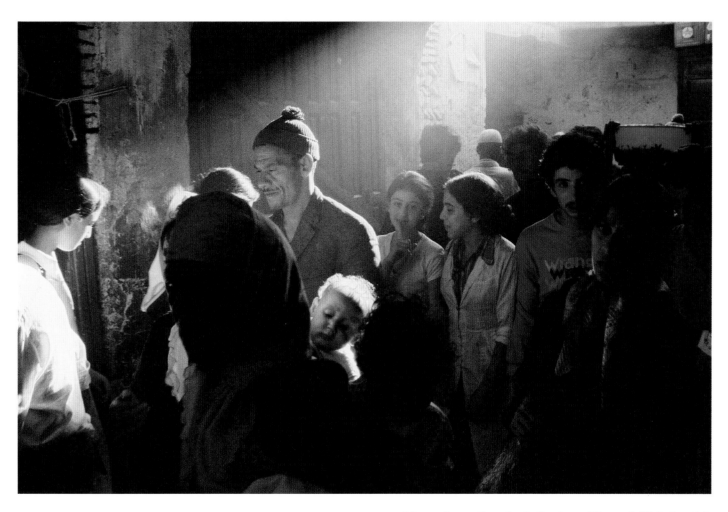

—Me and you I go look for her. (*Pause.*) This is—it's very nice. Is going—to work the, in the—light?
—No, it's for voices. For sound. It makes a tape. You see the cassette?

—How critical we didn't know at that time, but—she was in a room off the courtyard. And she was within sight of the window. From outside you couldn't get into the room. And there was a curtain over the window, I remember. And Fatima wanted to see her. And she finally persuaded an, a passing nurse? Or perhaps somehow by her own hand she contrived, through an opening in the window or something, to get the curtain away so that we could look in.

—And so they took us into a room and there was a man with a typewriter and he said, OK, tell me the whole story. He typed it all out and said, sign it. And they said, we will call her in and tell her not to go around your place anymore. We never saw her again. Well, Fatima was dangerous, you know when I was by myself with her I always felt threatened. Beginning when the baby was born. She said she would not work if the child were there. We didn't know what to do. She came in front of our house and started screaming to all the neighbors that we were barren. Anyway, apparently then— Hakima, in the middle of it she just went up to the roof, right? And jumped.

—Jumped into the courtyard?

—Well, there's two versions some people say she threw herself—and others say she was—going—getting away from Fatima and that's why she didn't notice the wall and then she just—

—Oh, I've never heard that version.

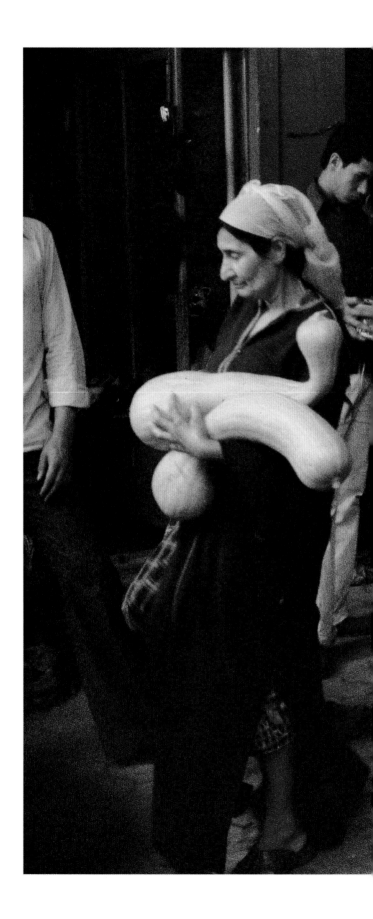

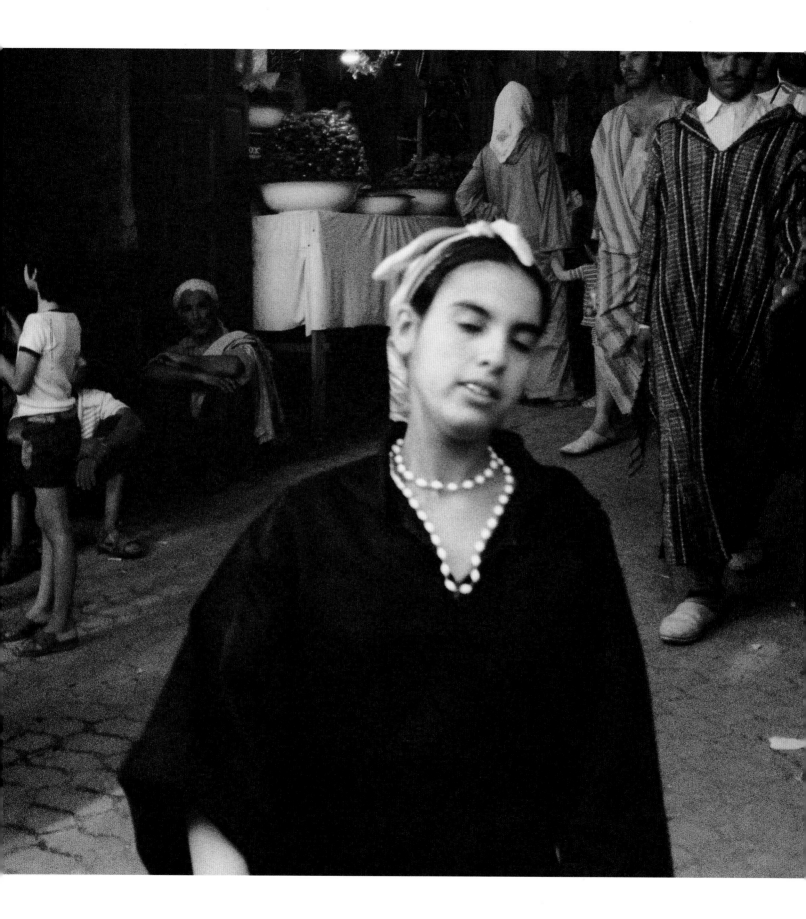

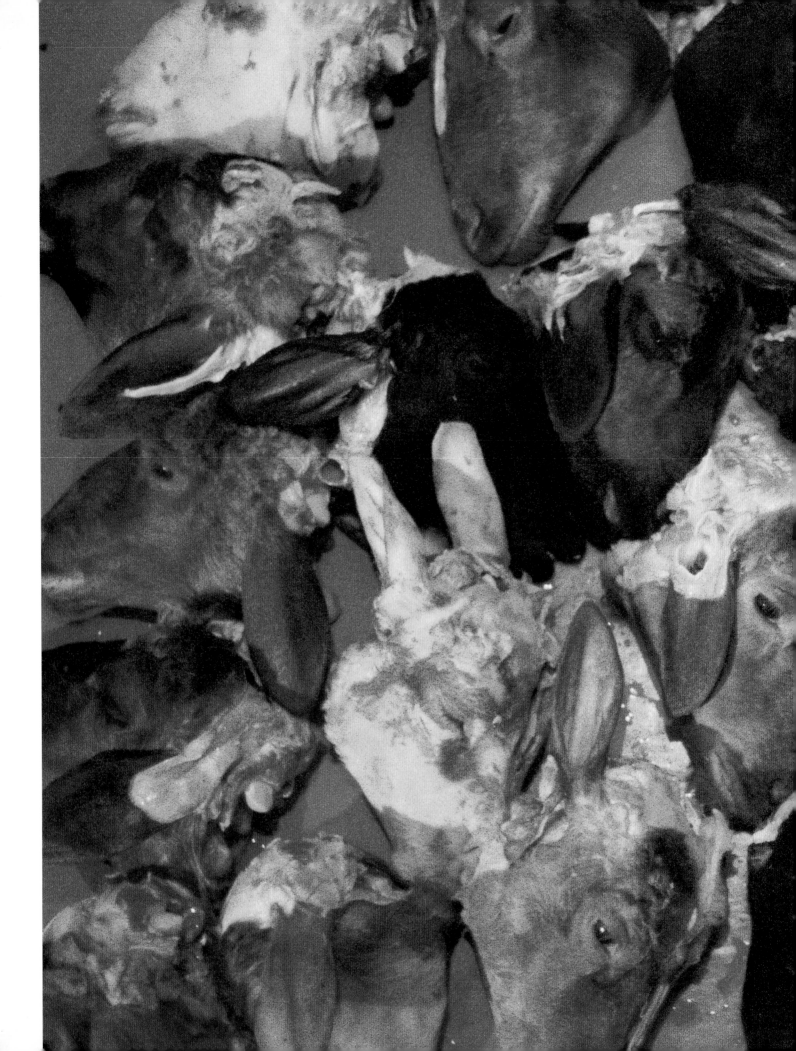

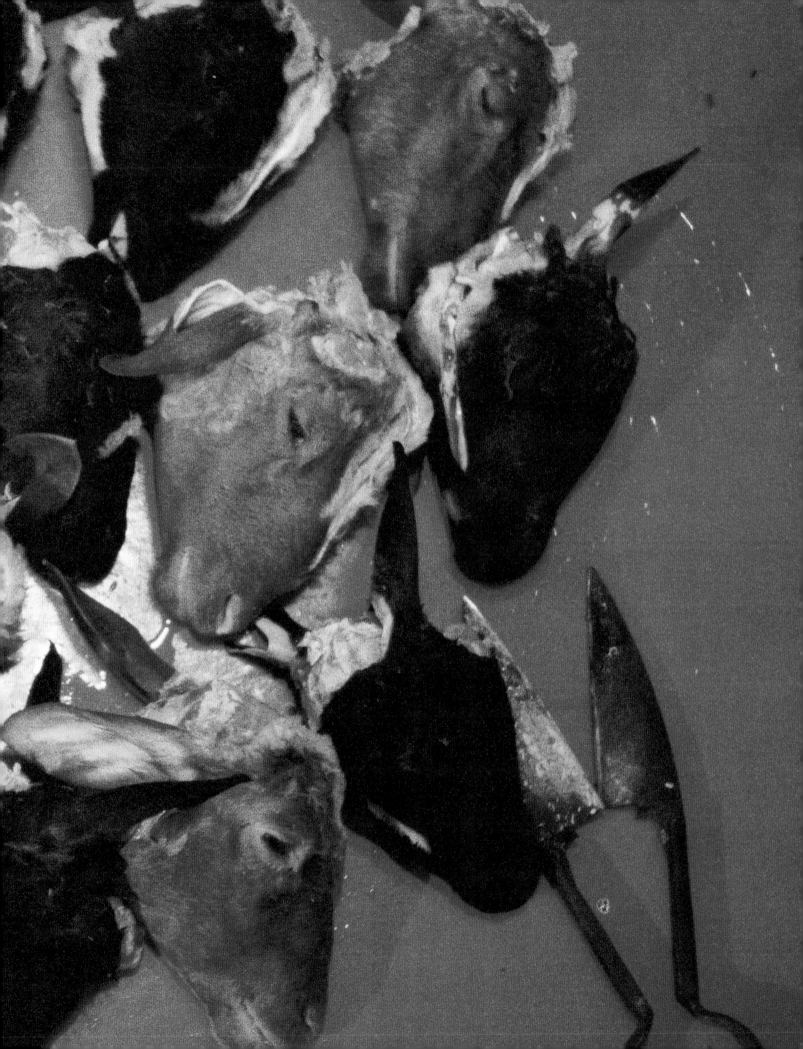

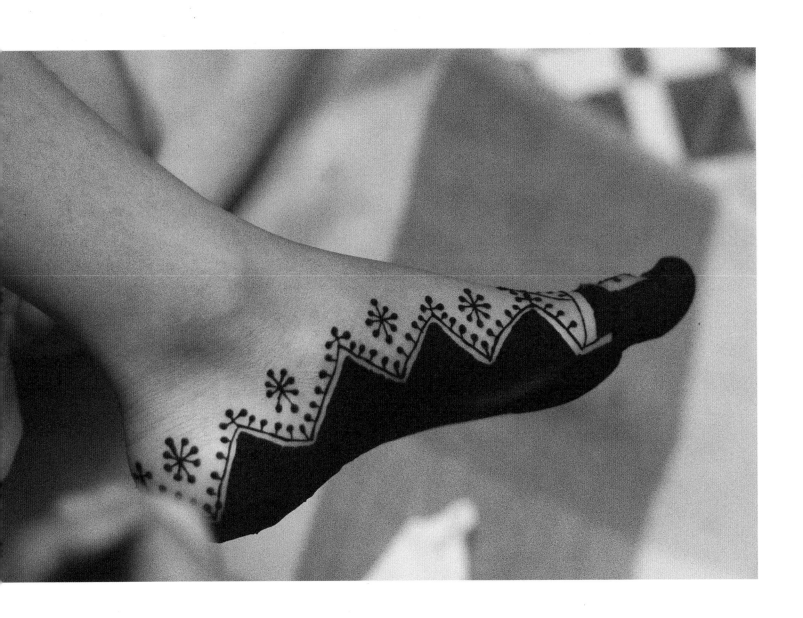

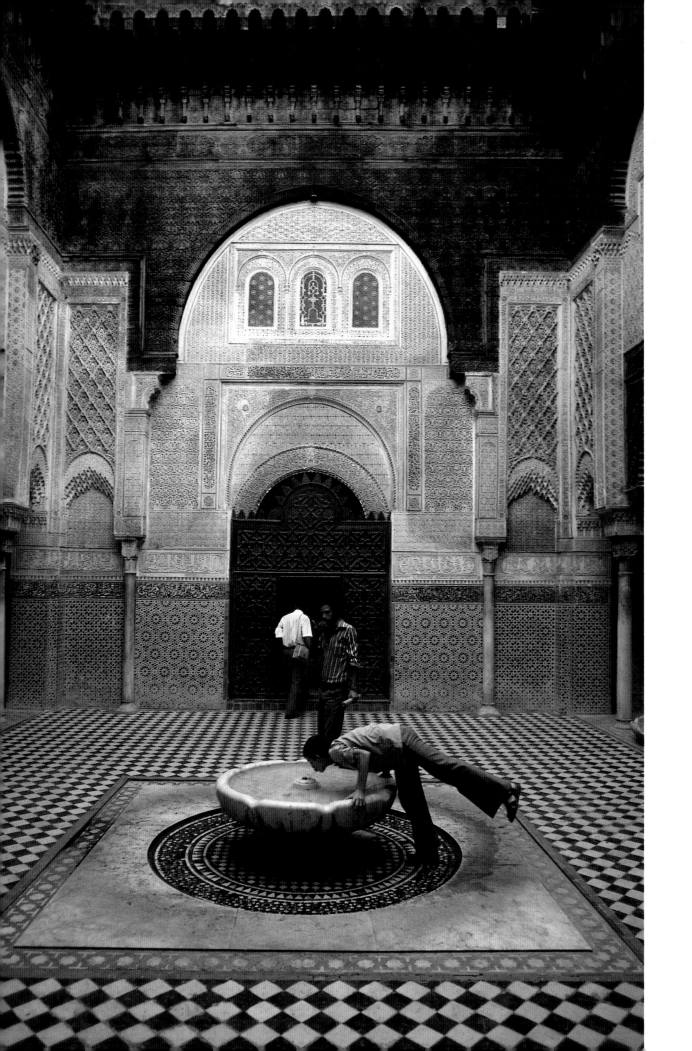

(On the tape, sounds of cooking. Then Hamid says abruptly to his wife in Moroccan):

—Listen to me. In the name of God, that day—

—*(She spits)* Look, look at this *marque!*

—Look: little sister Naïma, she's in love with me. She loves me, she wants to marry with me. The car, money, and everything there is. In the name of God she wants me, and the knife is on me.

—*Willi! Oh willi!* Get away from me. Go to her if you want.

—Laolalalalala! *(He jeers)* Say that again!

—You think I'm going to tell you no? You can go to her, do what you intend to do. *Lahounika, Sidi.* Bye bye.

—You bet how much? That girl wants me. In the name of God it's true. You want me to frighten her? *(He taunts)* The Citroën that's at her brother's. You want us to celebrate that? You don't have a brother like that, you, with a Citroën.

—God help you. Go to her. *Lahounika Sidi.*

—*(Laughs)* Watch me. That peasant: the table is a mess, piled with things. Oh, *willi.* Should I slap her? Watch me. *(He hits her hard across the face.)*

—*(Screams)* Lahounika Sidi.

—*(?: Inaudible.)*

—Oh, *willi.*

—And there I was standing at the corner of the window. And I look and I see a very white bed *(pause)*. Yes? With a *form* under the sheets and—the head visible. You see, and the covers piled up? It was a feeling of very white and very clean and very antiseptic. And there were just some *tubes* which entered in, you see, in this form. And ah, *(pause)* I, I, I sat and I looked and Hakima lay—just: *(sits on the couch, sighs convulsively four times, separated by intervals of several seconds, arching his body spasmodically each time).* It was the first time I ever knew I was looking *(continues in a whisper)* at someone who was close to death *(long pause).*

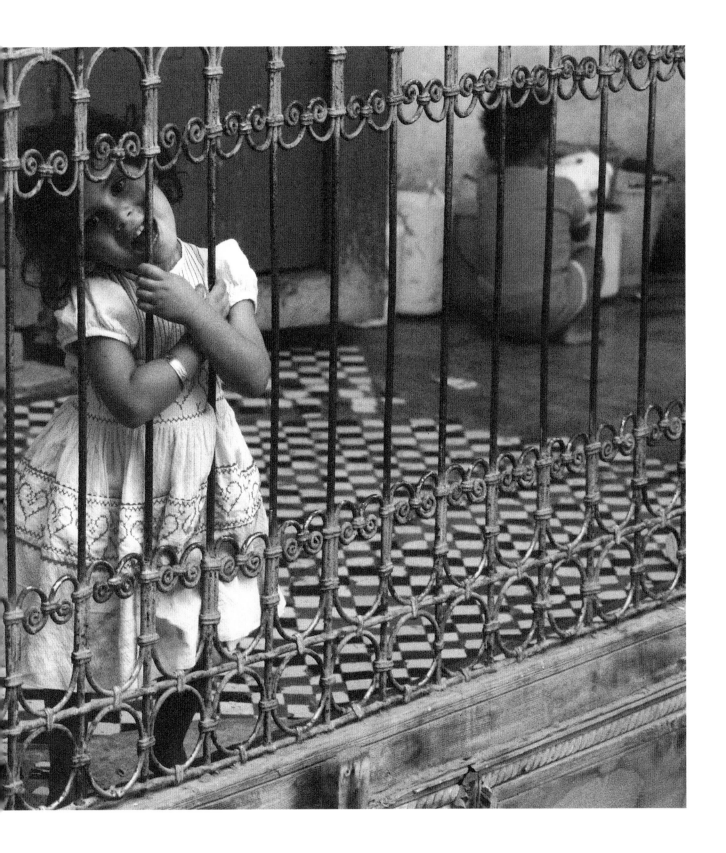

—At Ar-Rsif, no? It's him that's in the photo on her wall?

—No, that's Paul Ash.

—*Ayeh*, Paul, Paul, Paul, Paul, Paul. She loved him very

much. And he loved her very much also. She said he

was like her son. His photo is still there. Since he left.

—They were three, Lens, Paul, and Fatima. There's a

photo that brings them all together. They went to Tan-

giers together. They loved Fatima a lot. The truth is that

there was a lot of disorder.

—She insulted them, said they were without value. She

cursed them. She wished they'd go blind.

—*Haram, haram*.

—This one and the other, always.

—Them, they stood up to it well enough, in any case.

—She doesn't merit that you eat with her. She insulted

me when she gave me her girl, but God avenged me.

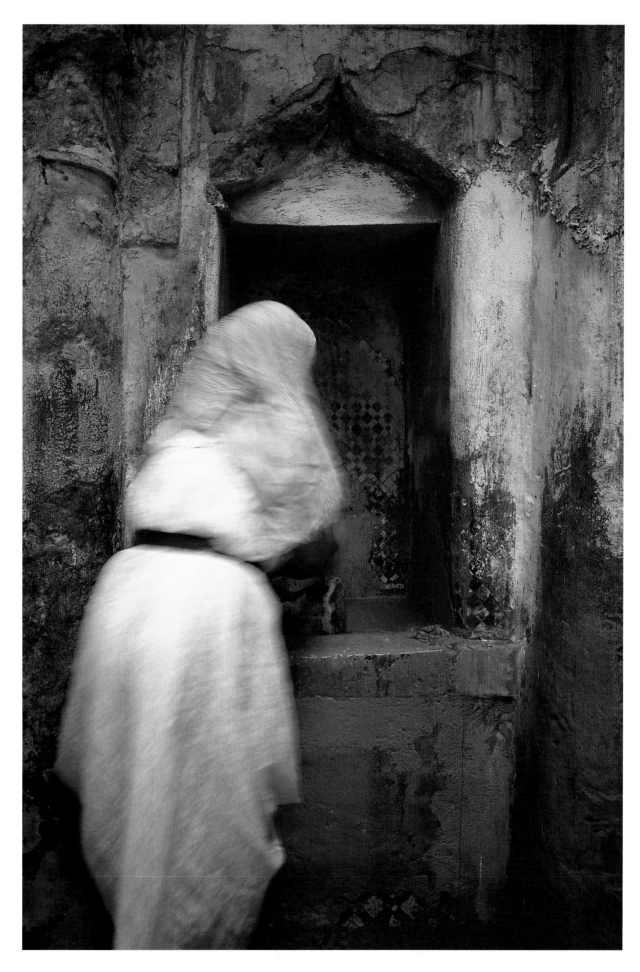

It is the summer of the Great Strikes. Unpacking her suitcase in the palace at Ar-Rsif, C. thrusts toward my face something round that she squeezes. A red pistil—a balloon concealed by suction inside an obscene mouth-hole—snaps in and out of a black rubber devil's head smaller than an egg: the same yellow eyes, the pointed one high on the crown. "Look, I have a present for you," she giggles, handing over the repulsive little toy. "They are popular in *Varsovie*."

She somehow got it into her mind, or somebody put

it into her mind—that—the *tattoos*—that she had done

on her chin, you remember the ones, here and here?

And on the forehead? And on her cheeks, here. That

these were somehow—*haram*, forbidden. And somebody

told her that they could be *removed*. And so she went

and she had some *dreadful* acid put on her skin, and for

the longest time it didn't heal and looked sort of disfig-

ured. And she was so obviously miserable, y'know, one

wanted to say, Fatima, y'know, you don't have to *atone*

for these things—God is compassionate.

"Look well
and rejoice
in looking,
Old Man
raising up
his eyes
to me.
See how I am
beautiful,
observe
and admire
my beauty
and how much
happiness
I hold for
everyone."

—*Ouezzani fountain*

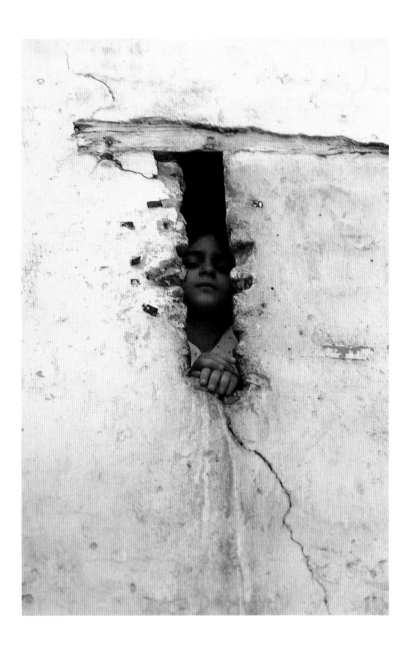

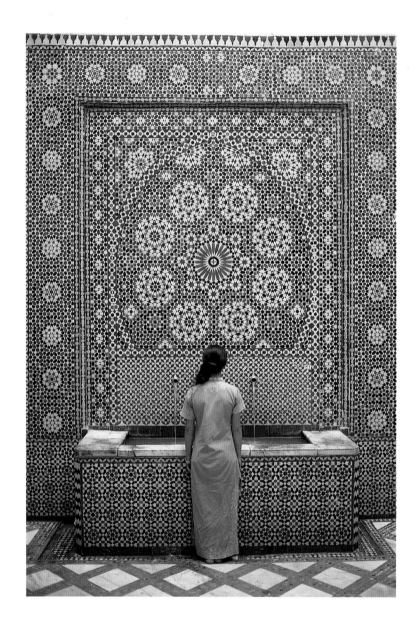

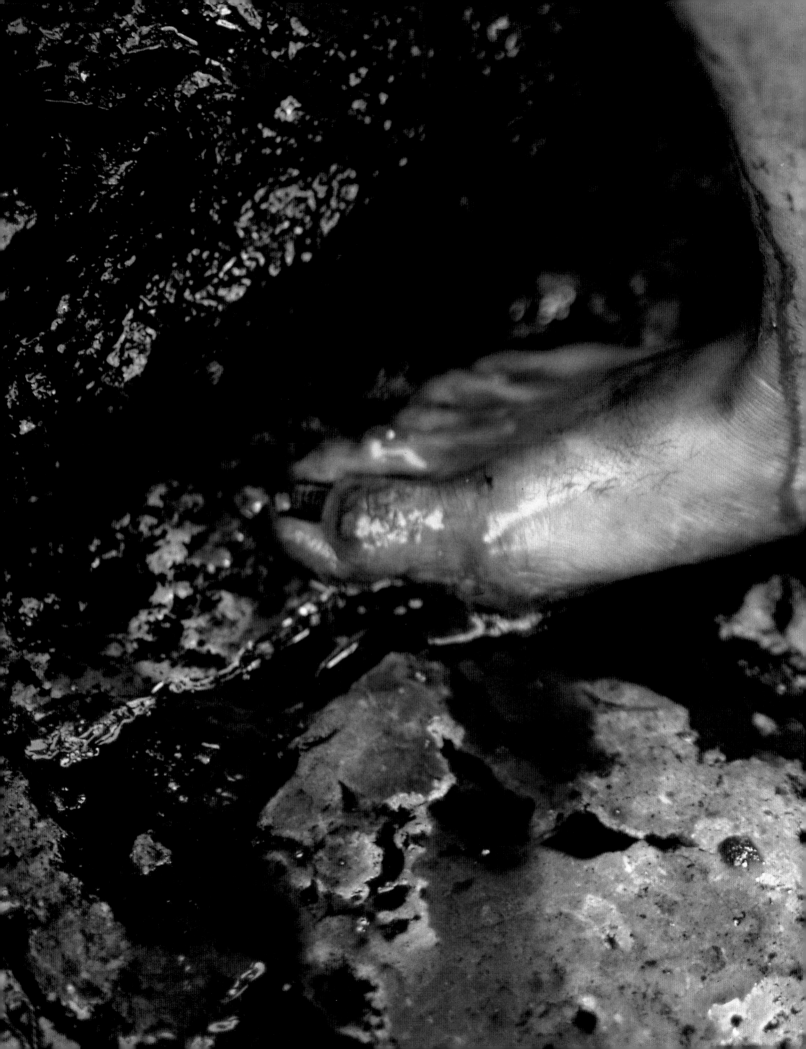

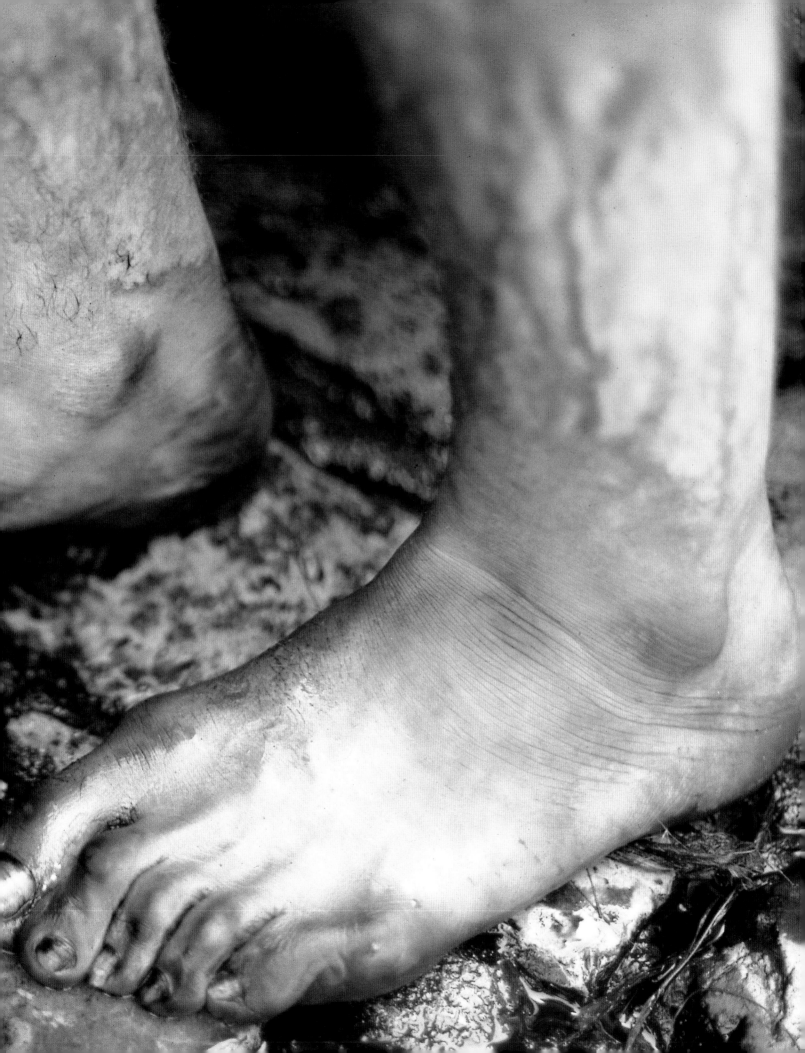

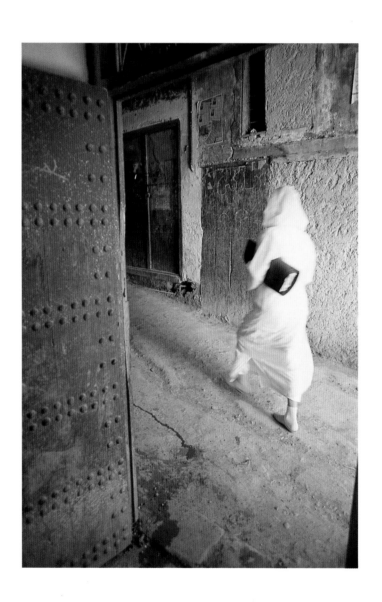

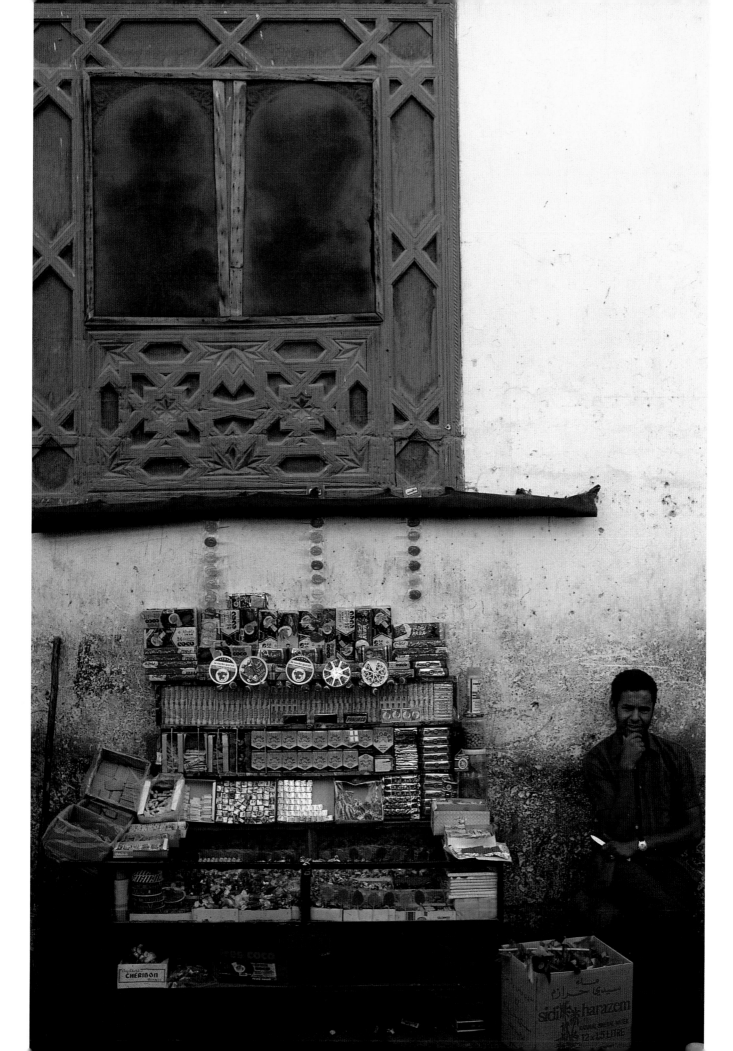

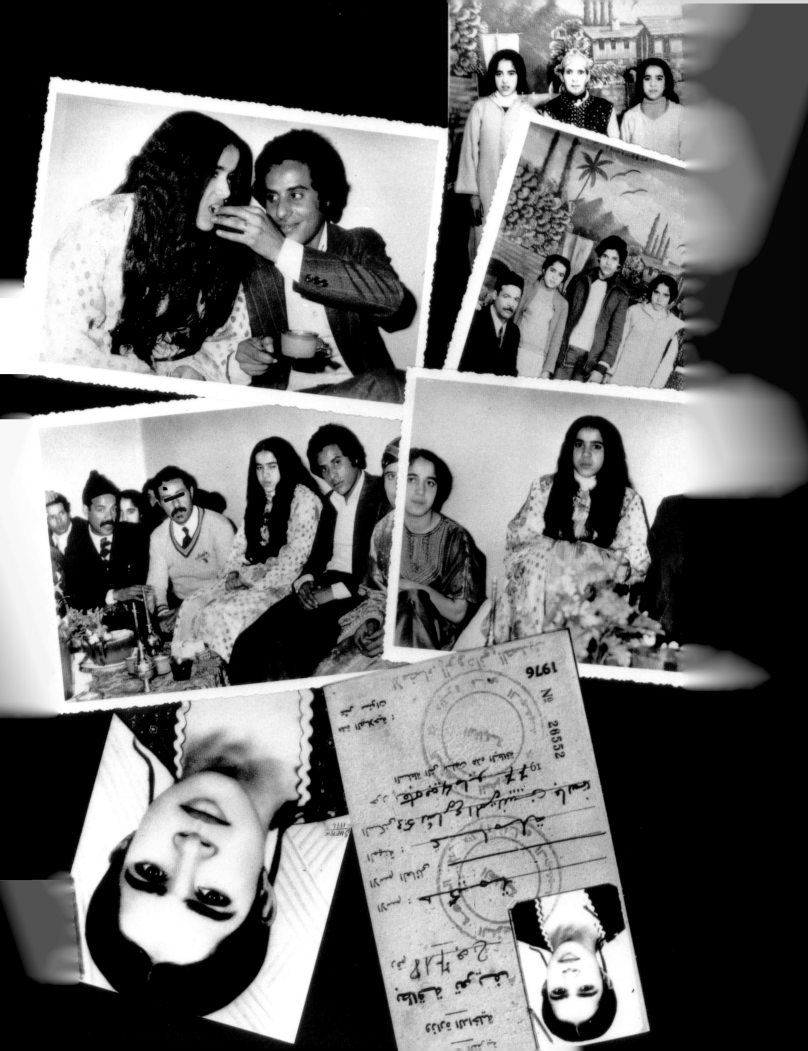

5. The Album

I take the album to the roof, for the light. Fatima squats, sheltered by the thin shadow by the wall. I fight to drive open my eyes. If I pause I smell the odor of my hair. The book divides at an habitual place, but it is not a photo of the girl. She remarks, "Voilà Paul Ash": a vaulted figure, a juvenile face haunted by a plea. Music scratches over the wall from the street, from the cassette vendor's. She turns the page: the wedding.

"It's him, downstairs, who photographed all that. Here's Lens, G___, and Paul Ash. This photo is of Paul."

"Did he photograph—Paul?"

"No, only for pleasure." She turns the pages. The acetate sleeves curl in the heat, disheveling the pictures. "And Hakima. That's hers. These are my photos. Hakima . . . " As I take the first photo of the girl I think of Fatima's last words to me: *My son, when are you coming back to me, my son?* That winter I bought a green, handpainted scarf for her, but lost it long before I returned.

"That, that's a photo of Paul and me in the country. I had flowers in my hands. I had just whispered something in his ear. I had a shawl over my head. It was very cold . . . And this is Paul and me at the airport. Paul was going to Egypt. There's the suitcase . . . And there's Hakima. She was still a baby, she was six. There she is." I photograph it and hand it back to her.

"Hakima's mother died when she was forty days old. Afterwards, I adopted her. That's a photo of Hakima. No, not that one, that's her sister. It's there we made the marriage contract. There she is, when they exchanged the dates. Here it's her that gives him the date. All those here are his family and mine."

"She was married in Paradise."

"Now this boy has married her sister, Hakima's sister. Here's the sister."

" 'The destiny of one is not trod by another.' "

"That was the *fête des fiançailles*. These photos were not yet developed, they were still at the photographer's. She had not yet seen them."

"Fatima, you, you say that the heart of the believer is his messenger."

"Me, in the beginning I didn't want her to marry. And the day of the marriage contract I wasn't well dressed, I wasn't elegant like the others. I cried in the corner. The room was full, there was the photographer; and me, I cried, as if my heart was telling me something. People asked, why are you crying? You should be happy. And me, I cried because of the separation, the coming separation. I thought it was a separation in life."

In her room she brings a towel. My eyes seal. I think no more about it. I sleep. (027: *Sound of a loudspeaker turned on outside, a hum reverberates. A male voice sings loudly, then falls to middle volume. The music continues.*)

—The next night it was back. But now, instead of being

confined to the room, it seemed to be coming from out-

side, precisely, from one of the two big palms in the

front yard on either side of the fountain. Well, I crept up

to one of the palm trees exactly as I'd crept toward the

corner of the room. And lo and behold, it changes to the

other palm tree. Well, it's one thing to change from a

corner of the room to the middle of the room. But from

one palm tree to the other, and that the tree was very

distinctly, very clearly the source of the sound, was

very strange.

(*Loud, distant knocking.*)

—The door.

—Yes, the door.

(*156: the tape ends.*)

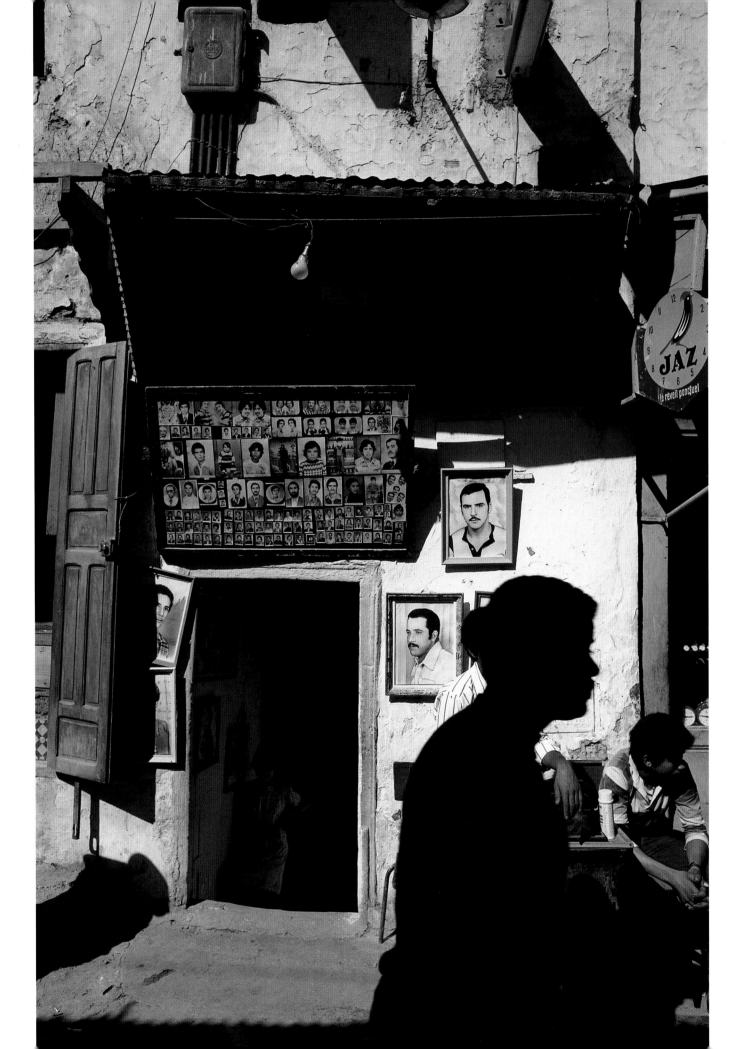

When I wake, I want only to leave as quickly as possible. Under the double portrait with her sister, Aïysha, I open her hands palms-up on her lap. They seem to detach and slip from her, as if prints of themselves. Each palm is black, a pool, a one-sided glove, cloven at the wrist, the five fingers fully sheathed from second joints to tips, more imbued than dyed with a black confounding countless reds, innumerable coats of henna, ritually drawn, repeatedly cured by fire. They are not palms but secrets, shields or scepters, more two virile signs than hands. Her feet are the same. Her look alters, sympathy drying into triumph. It is the last photo. (*Sound of a liquid being poured from a height.*) I must take a stinging glass of cardamom-scented coffee: *A visitor who does not eat poisons those who do with his eyes.*

"It's always a little strong, your coffee."

"Too strong?"

"No, I like it like that."

"I like it like that also. Very strong. But it's been a long time since I stopped drinking coffee. Since I was at your house." She turns to the middle of the narrow room and gestures over the floor. "My sister died from the charcoal. The *kanoun*, the charcoal—to cook, before there was gas. She died here. My husband put her there. And that began to come out." The breath? Blood? She mimes wheezing and puts her hand to her throat: asphyxiation. "They said it was the charcoal, at the hospital. Hakima saw that. Right here."

—The moment he entered it, Schmid chose the house to shoot the film. He knew nothing about its story. No one told him, of course, because it meant money, and besides, we all had roles . . . And anyway, since the sacrifice there had been no more—but that, that repeated many times—at least six or seven times. And I have witnesses.

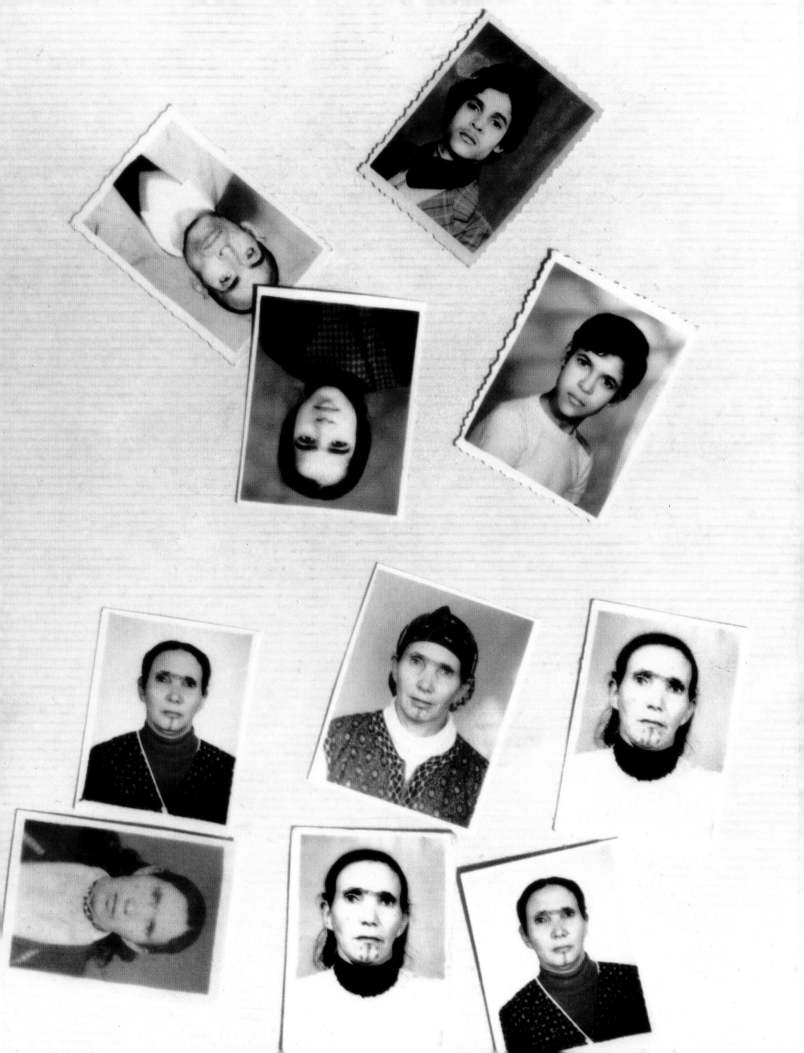

At last emptying the glass, I thank her for the album.

"You can take your photos. I would have let you photograph her in her coffin if you'd been here. What do you want? Hakima's already dead. Him, her husband, poor thing, he didn't know. He learned of her death a long time after. After the burial. He went crazy. We were alone, Hakima and me. I couldn't pass the night far from her. But since it's God's will to take her to Him, look at these photos that I have of her. She is still alive for me. I have her things and her photos, and all the rest."

—Apparently there was more than one. And they had names. That's what the neighbor woman said.

—Do you remember their names?

—Lila . . .

—(*Simultaneously*) Laï la.

—Fatmasidhena—

—No . . . (indecipherable)

—Aïysha, Aïysha, Petite Aïysha I think.

—And besides the French woman she said there was a couple buried under the stairs.

—She, yes, she said at the outset that the house was build of, of, how they say in Arabic, on the back of the poor. First, the owner was a *kaïd*, a chief. Of course he had a number of people put to death.

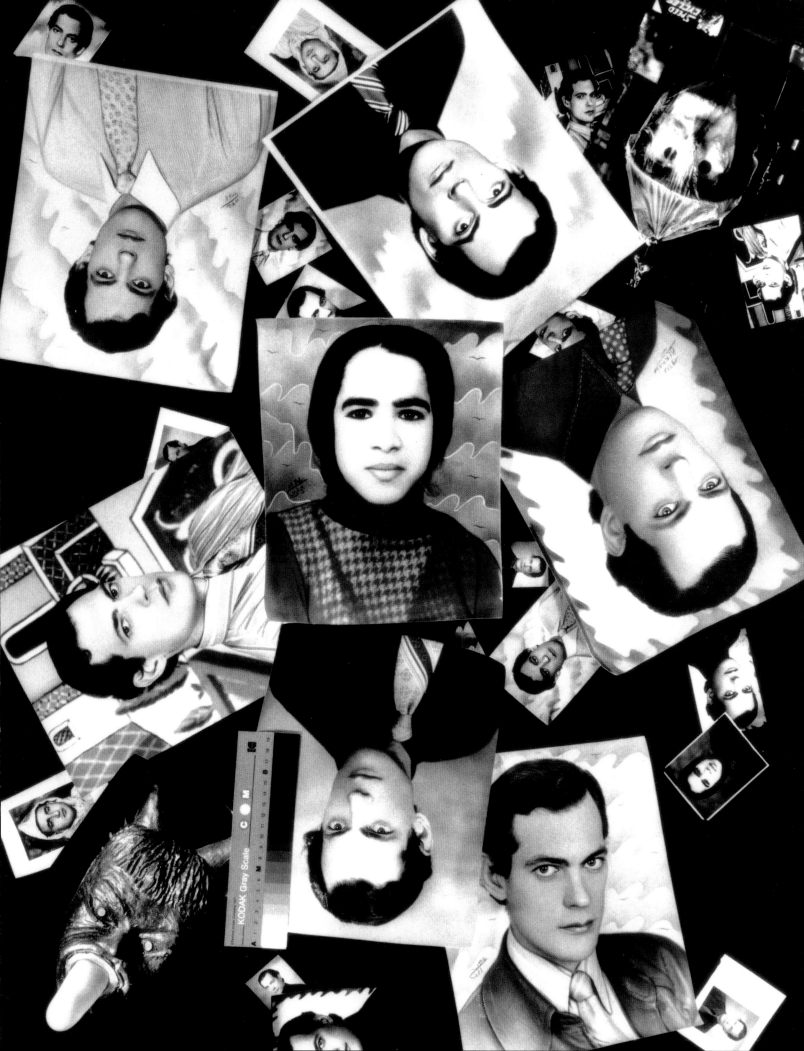

"I had no luck with the first, and none with the second, either." He calls to Fatiha: "Turn off the radio, little sister, that doesn't help him in his work . . . Poor Hakima, she had no luck. Deep down, I didn't wish for her to die. When I learned of her death I was a little shocked, but I didn't feel much. Her death surprised me, but it didn't really touch me."

"Fatima said the girl was loved, Abdulkader."

"No, no, no. Love, that never existed between us." Destiny? "I don't believe in destiny. In the end, I suppose if you're Moslem you have to believe."

" 'If the individual's will is set on finding out what's behind God's throne, it will.' "

"Completely agreed. If we wanted to conquer death, we probably could. But the life without sadness, without problems, is not a life. You have to sacrifice. And even steal. The man who steals makes a sacrifice also, a great sacrifice." He pauses. With a glance toward the door, he says, "You remember the song on the radio? You know who that was, singing? Once I was in love with a girl, but it didn't work out . . . When the baby was born, my brother— he's a musician—he named her Nehema, because it reminded him of Naïma Samir, who is a very great Moroccan singer, in the hope that when she grew up she'd become a famous musician like her. But I was also happy, because her name would always remind me of my great love." He listens again for his wife's step. "Three days after the death of her sister I asked for my wife's hand. I saw her during Hakima's funeral. I'd seen her once before, during my marriage with her sister. I preferred this girl to all the rest. Automatically. They accepted. Three days after the death of Hakima. We had a very discreet engagement party. We slept together. I found her deflowered. So then she told me all. It was someone from her family, her mother's family, a police officer, a gendarme, two years before she met me. She dared not speak about it. The girl was alone at her cousin's house and he raped her. And she told me, 'You can break off everything if you want.' But I thought it would be shameful to abandon her. She'd already made a sacrifice. So I sacrificed something. Do you think he would have married her, the other? Do you think he would have taken a second wife, and that his wife would have accepted her? She said to me: 'What will be my future? Nothing but the street. If you can make this sacrifice, and work for the Above, this will pardon me, and there, we'll live together.' And now I feel a love which is very strong. We try to forget."

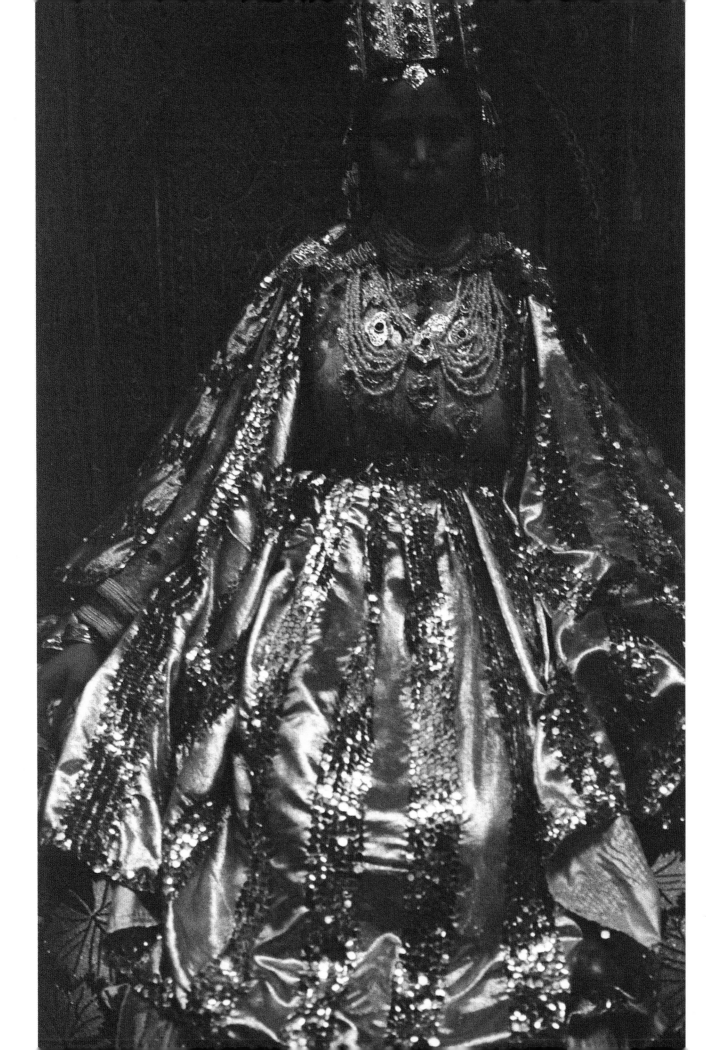

6. UU (Youyou)

Fatima takes hold of the arm of the friend accompanying me, and says in Moroccan:

"Ask him if he wants to spend a month with me. I don't think he would."

"I don't know. He's a butterfly. You know, he doesn't warm a place, like they say; he's always elsewhere."

Fatima begins to cry: "Please tell him, tell him to come live with me if he doesn't have anywhere else to go. He can come in my room. I'll give him the key, and everything there. He can work during the day, he can go out and do what he likes. Then he can come back at night and make use of the key." Passing along the balcony, she pauses at a spot: "Then she fell, her head was there, her feet on that side."

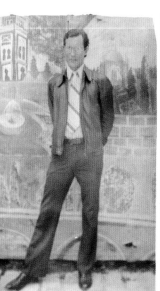 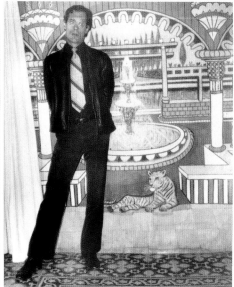

He was *behind?*

—*Derrière.*

—Holding her in his arms, like this—

—Yes . . . his arms *over* her arms.

—*Over* Hakima's arms. And then what? He tightened his arms?

—Yes, exactly the position, if you will, of a lifeguard who saves someone drowning. Thus he crushes them, once out, or even still in the sea, he takes him like that, you see? Pressing on the arms and the chest at the same time, to keep him from, from moving to left and to right.

—And then she hemorrhaged.

—Yes, immediately.

—What? Did he want to give the hand of God a push? Or maybe it was simply to lift the body and place it on the—

—No-no-no—*non, non.* I don't think so; it was especially for—they have this mania of thinking that when a person is bleeding internally, they must make it come out at once.

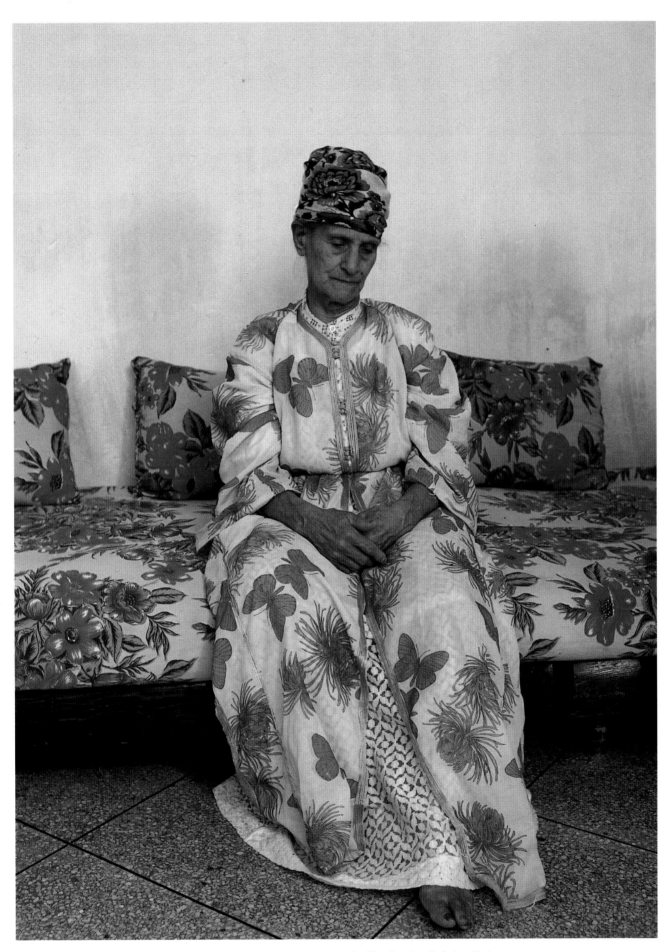

"Death is the union of forces." —*Graffito,* fonduq *Rehaba, Sagha*

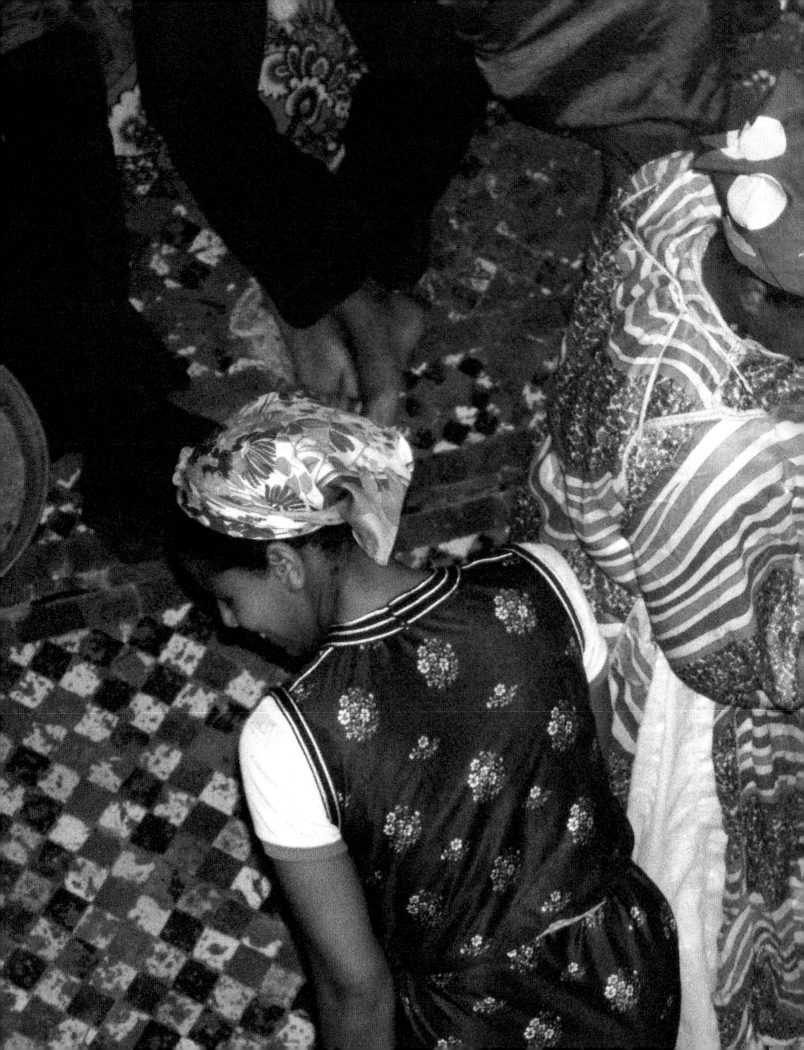

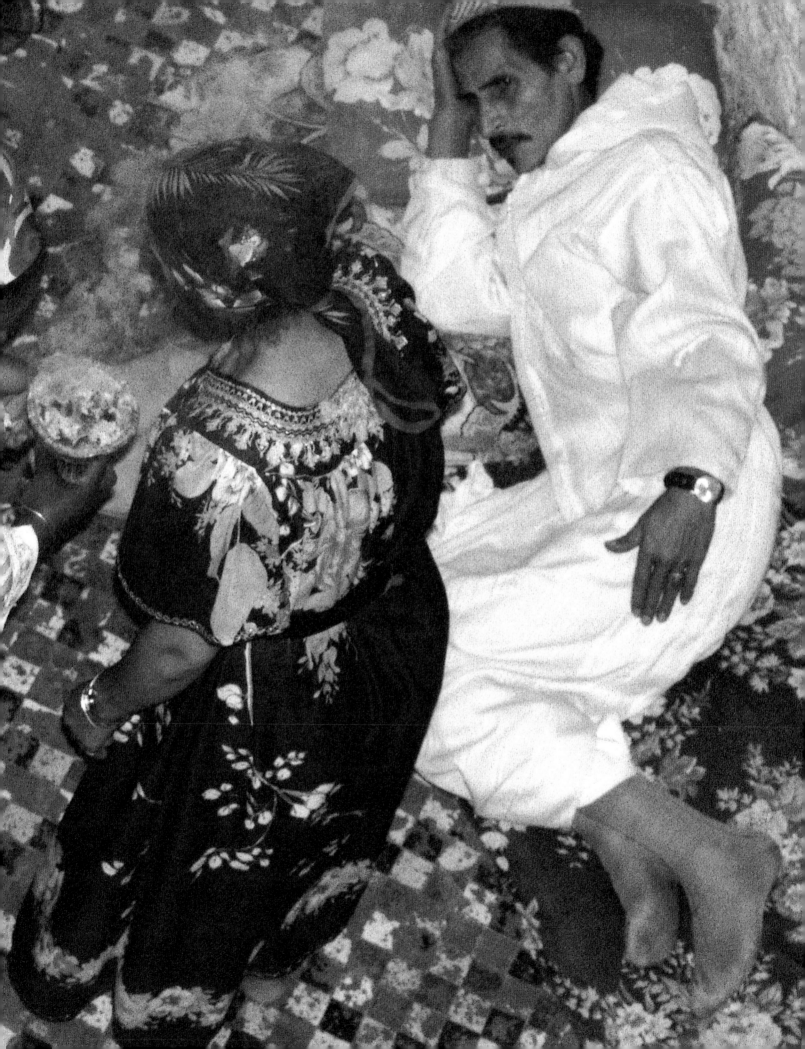

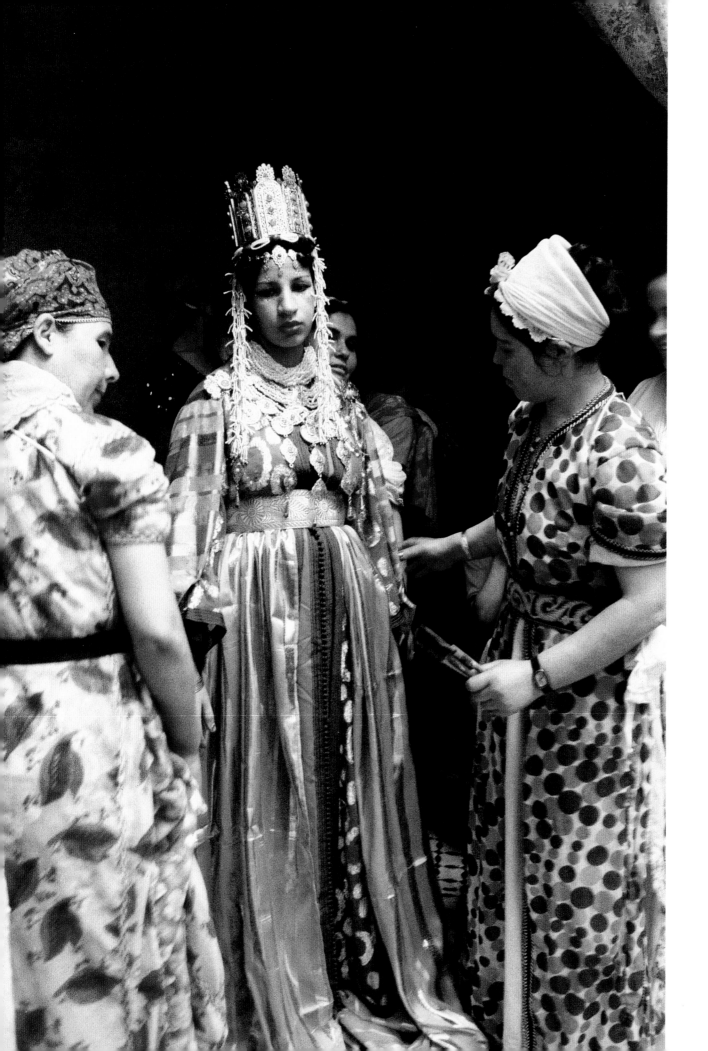

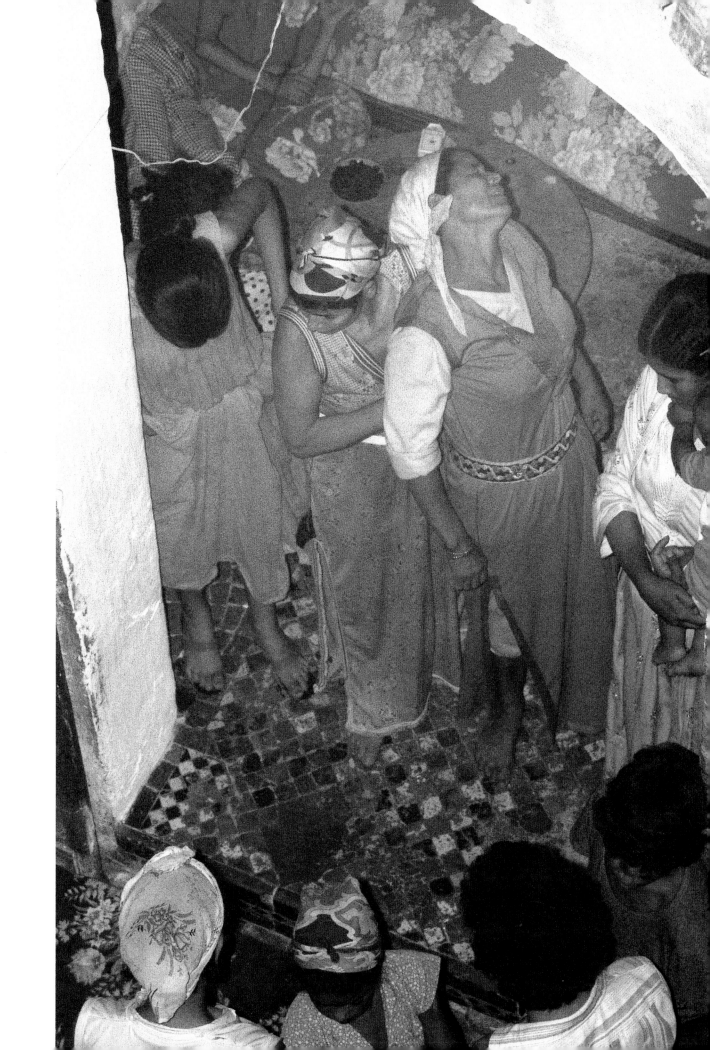

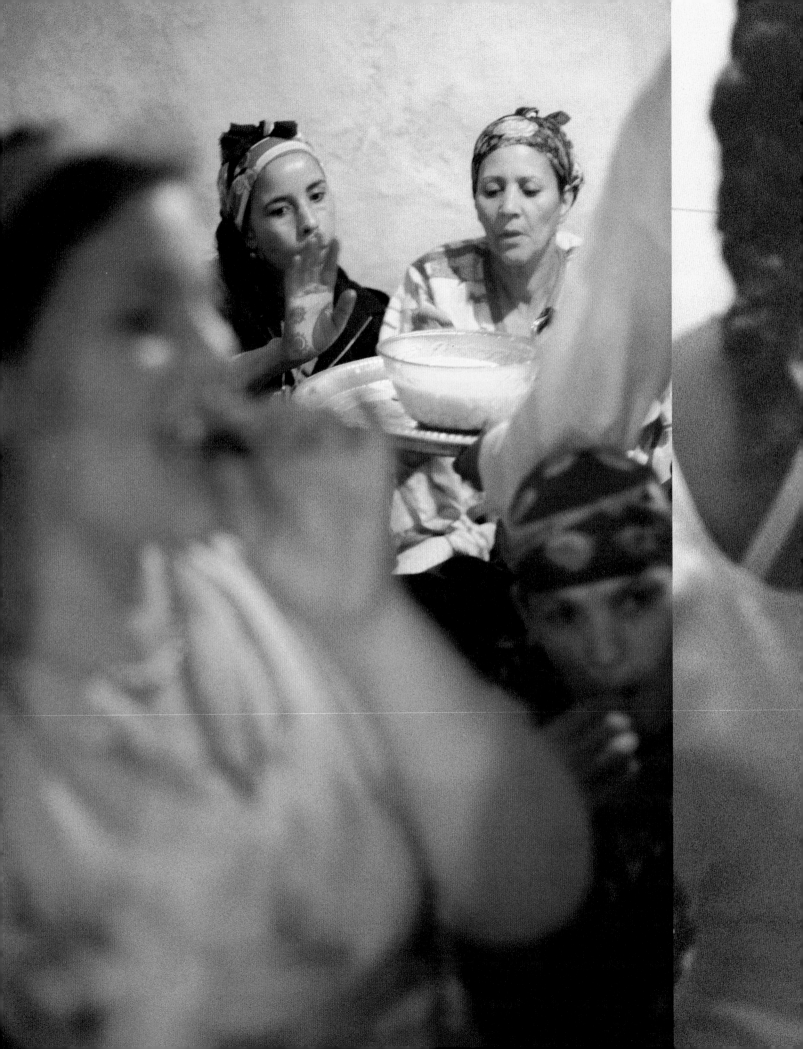

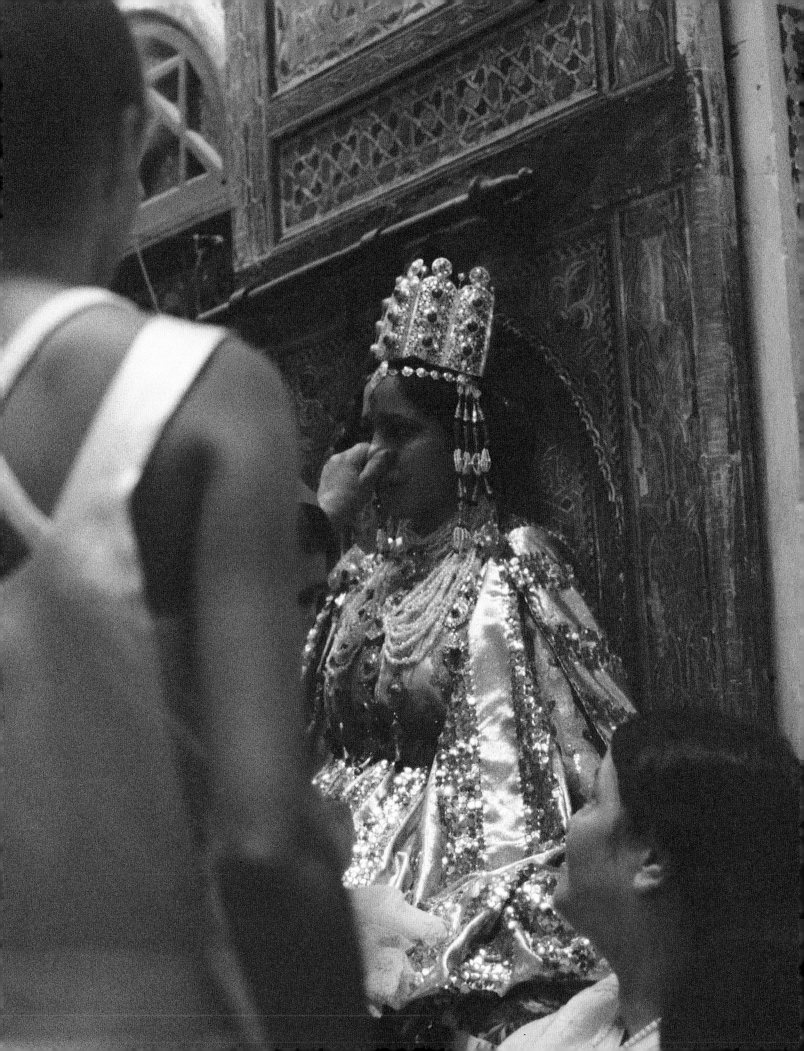

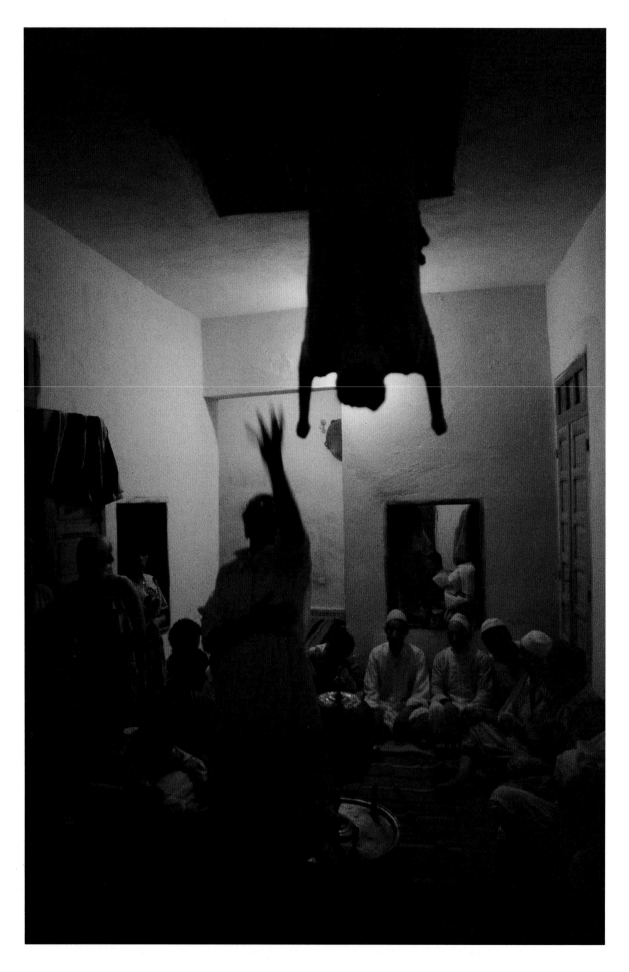

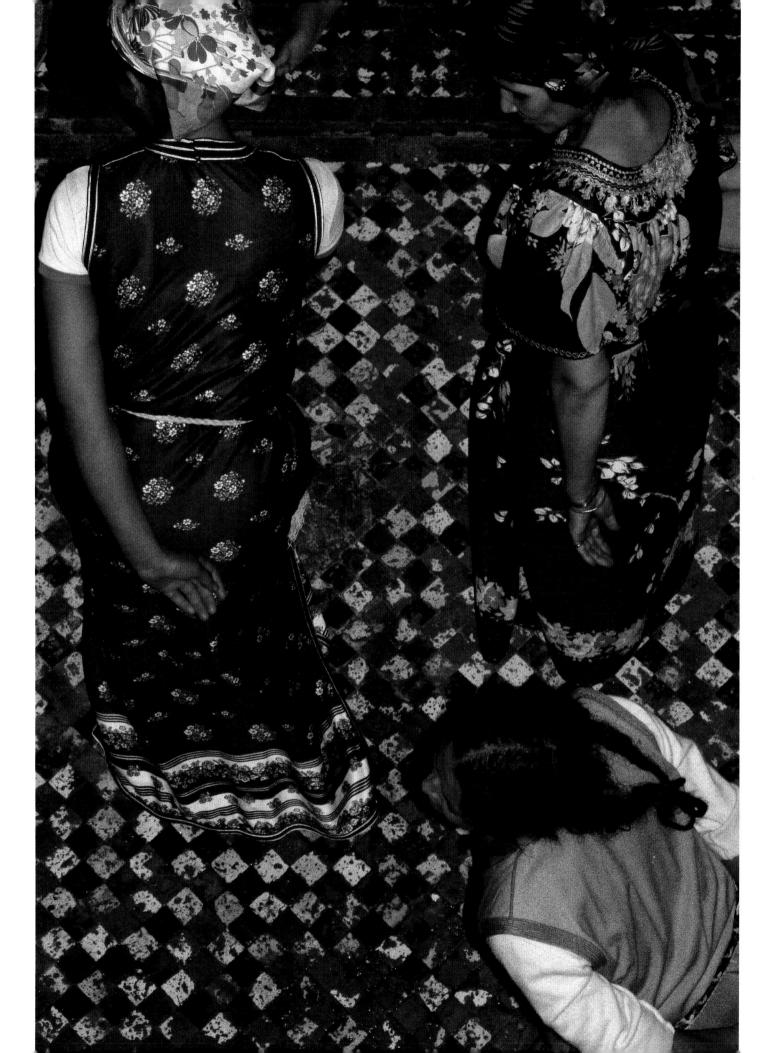

7. The Wound

"Oh my wound, oh you, my wound,

I've run and I've rambled,

and you're never far."

—*Naïma Samir*

She dreams she is betrayed, or will be: the image is clear. I insist she merely remembers a photo. We quarrel; reunite. Aterwards, I crave a—the moment I reach the street I hear her call my name. I freeze. The voice is distinct but far—up, to the left? She calls three times. I cannot see her. Memory plays and replays in my ear, and suddenly oppression wells out of the sound itself: abducted. She is not far but imprisoned, sealed in something metal. Terrified, with each passing car perhaps holding her, that if I do not see her now, she will disappear forever, I take the nine or ten steps to the *tabac*. *Still* nothing happens.

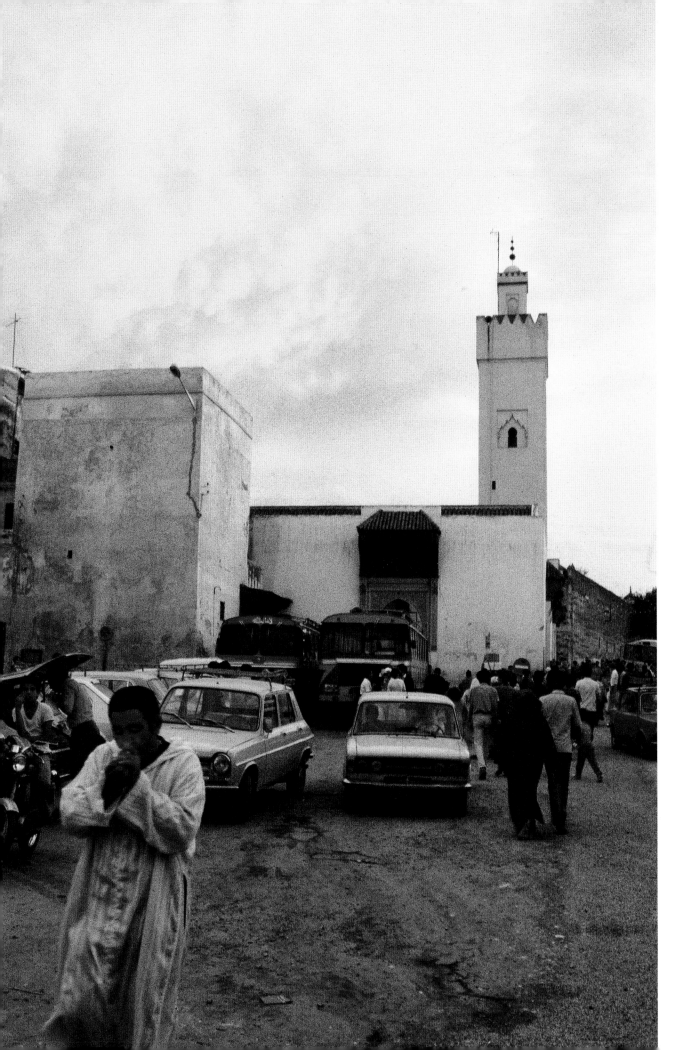

I stand on a lakeshore, looking toward a forest where a figure has appeared and approaches, emerging from the dazzling, low sun of an afternoon which has ceased to advance. I realize that it is her last witness, as if it had been announced. The wait is not long, but its ambivalence redoubles the unreality of the forest, of the lake, and especially of the haloed silhouette of a man, his head a veritable eclipse, who now stands before me—as if they were all but representations. Face to face I recognize Lens, and exclaim his name. My joy at our reunion is quickly muted. The other, as if the name alone were insufficient to prompt me to "see through" the disguise, changes by telescoping in rapid flashes into another appearance. The more directly I try to look, the more voluptuously the images cascade . . . Who in all my life had so resisted—not my recognition, but, by inversion: recognition of me? If not commotion, a strong attraction arises from the emerald lake, where a magical event is unfolding near a wooden structure, its feet in the water, on which hang crossed ears of corn tied with lures of feathered hooks. The other warns me not to touch. Despite the taboo I watch enthralled as, under water, long, slim cones or cylinders separate and float one by one from a mass resembling a pile of joined logs or branches, like a fasces. They right themselves and hang like masts under the surface. Fine triangular membranes or fins unfurl like sails and the masts tilt again, magisterially slipping away into the depths. "For the king!" the other says, alarmed that I stare. A woman's voice answers, *"Des carpes."* *"Oui,"* I reply, *"ce sont des carpes, je comprends,"* implying my vow of silence, unbroken till today.

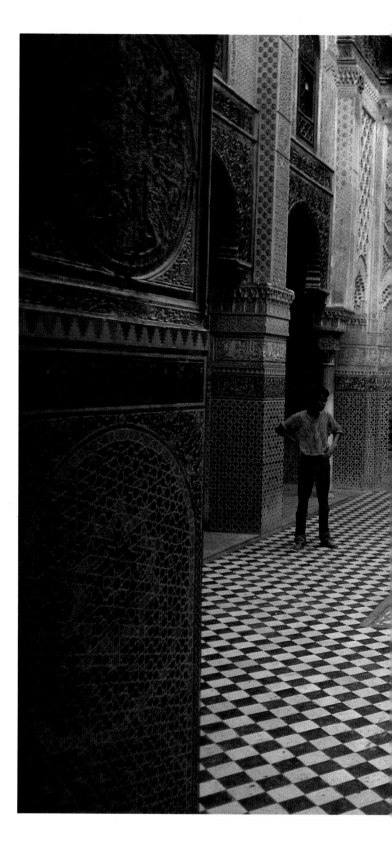

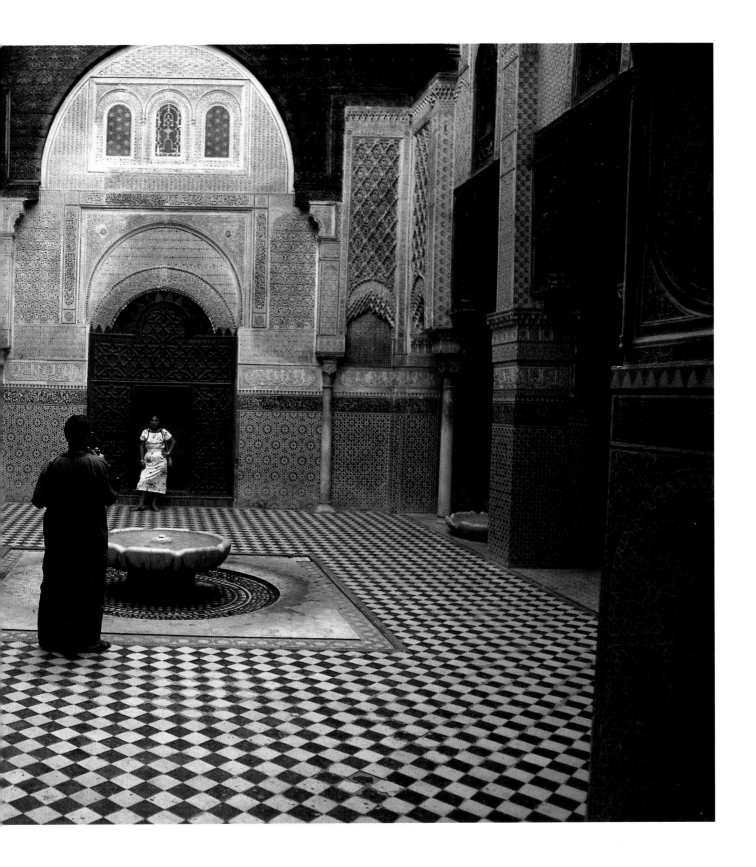

The first two frames of film are separated by but hours. I photograph the Pyrénées from 32,000 feet, a black jetty in green last light damming an ocean of cloud which stretches south into the night . . . and, on the way to the terrace, a row of cushions across the floor of a room too hot for sleeping, dike to a sea of white fleece. All the pillows of the house, breathing.

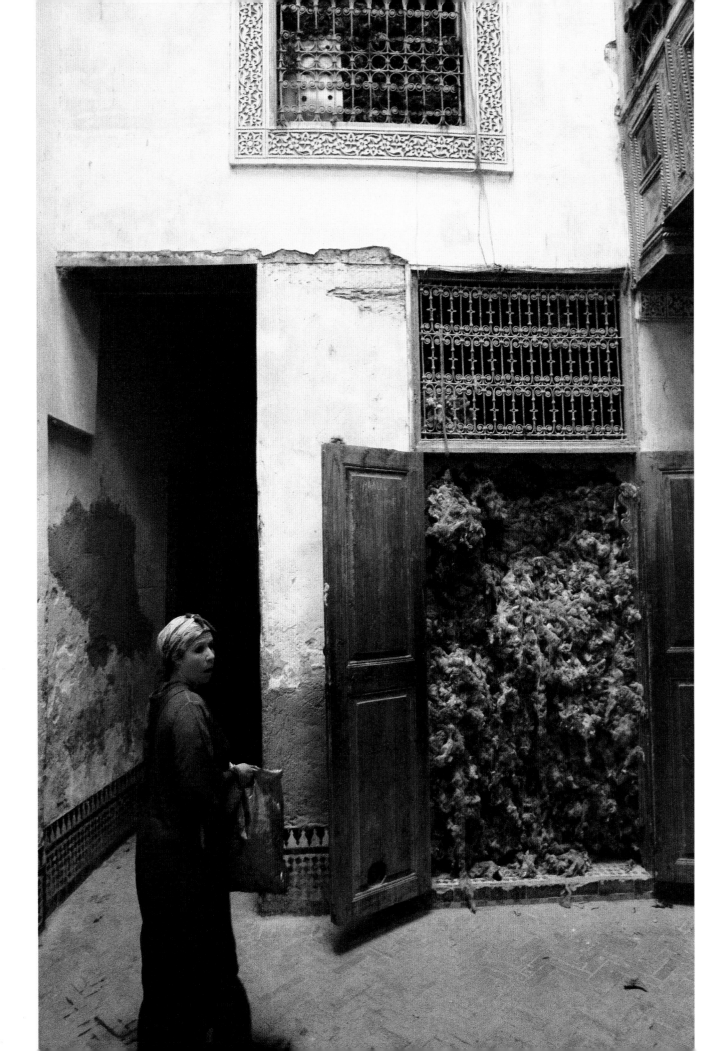

—They filmed for six weeks. It's too bad you couldn't

come. Everyone in Fez was there, of course. Even Paul

happened to come back, Paul, Paul Ash. After seven

years. Did you know him?

—People always mix us up. He came before me. I never

met him.

—Paul is one of the two or three persons I've met in my

life who most people would call crazy, who seems to

have an uncanny power to—there's something they can

project—that one can feel? He came to the house. But

seemed lost. He talked about Fez, seven years there

and seven years away—now he was at the crossroads

again; all these architects were throwing him out and—

should he see Fatima or not? But his eyes roved the

walls the whole time and in a distant voice he kept

punctuating the conversation with, "Have you ever no-

ticed the blood—dripping from the walls of this

room . . . The blood . . . the blood . . . everywhere." And

then he'd look at you.

—The make-up man, he was a great make-up artist,

he's well-known, he—a fantastic guy, a Brazilian. The

scenes at the house were the last stage. Thus we came

at the end; he had never set foot in the house before

the day we started shooting. He enters and looks all

around, and says, "*Merde*! I can't stand this house!" He

wanted to run.

—If she comes and they want me to divorce, then they do what I asked. She cannot take my son.

—I told you what the answer was. I'm serious. In the name of God, we ought to have thought of it before. It would only cost eighty *rials*. And she'd do something for you. Believe me, the idea's fantastic.

—I swear he asked me to go to see her. But you know, those things are too strong. She told me to find a little plateau—

—You recorded the woman?

—Yes.

—Where is it?

—Bill, do you have the cassette of that woman?

—No. It's in Paris.

—She told me, "Brother, this girl you follow, you should abandon her . . . Good will, she has none. She is using you." That's all. Everything the *shuwwafa* said was true. Everything. I don't sleep nights. I think about the scandal. When I imagine myself face to face with that woman, everything she said comes back. Right now I'm waiting for the end, the end is very beautiful. She told me that all this will pass, all will end well. She told me, we are going to leave. She told me she could go to heaven and come back to earth, "but she will come back to you, kissing your hands, her lips to your hands. She is always under your shoes; she cannot do otherwise. She doesn't know what to do if she doesn't come back to you." She told me—it's that, me, I hit her a lot. It was a woman. That's all, you know?

—He was obliged to stay there because he was the

make-up man, he had to touch up the actors between

takes. But every time he had the chance to go out, he

did. He didn't like at all certain places in the house, he

told me: "Here I am—there's a person who immobilizes

me here. I can't stay here."

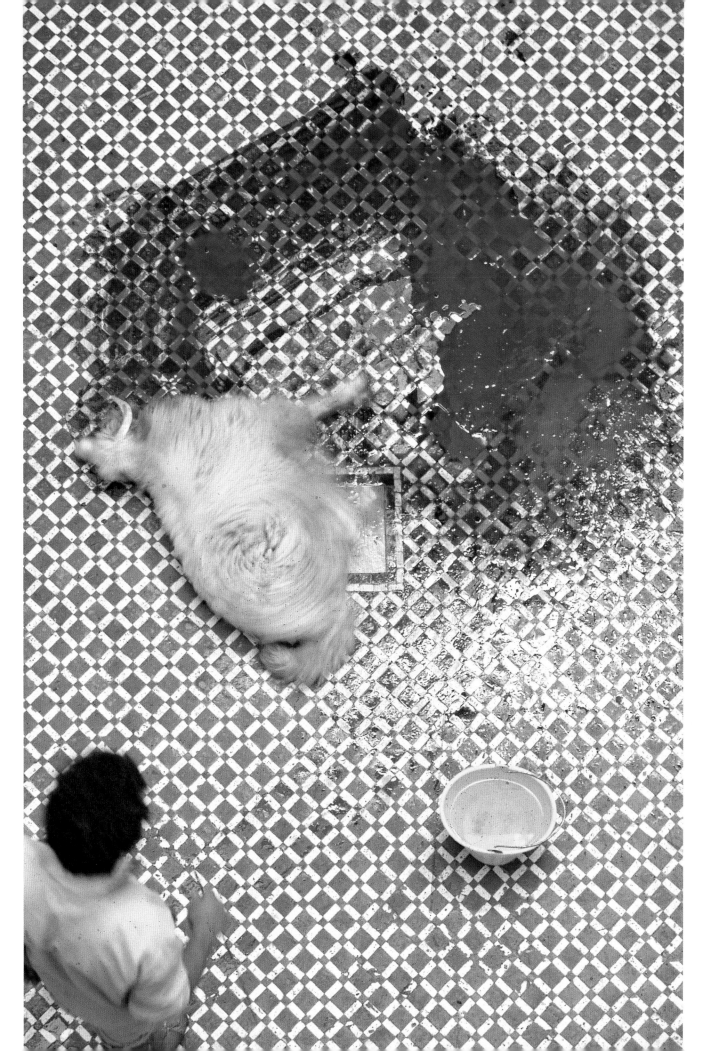

—The famous "room of metal" where you and V____

were attacked?

—There, no. He never went upstairs. It was especially

in the library.

—Where you had the first of your experiences.

—Yes. It's that—me, I had my experiences in the room

next door, rather, the Moroccan salon, the "Mirror

Room." But what he didn't like at all was the Moroccan

room, which is a magnificent room, it's very beautiful.

And the library, where they were filming, just beside.

And the fountain. He didn't like—he looked at the foun-

tain but—he didn't feel at ease *there*.

—That could be anywhere in the house.

—Yes, that can—it can be *who* one is, also.

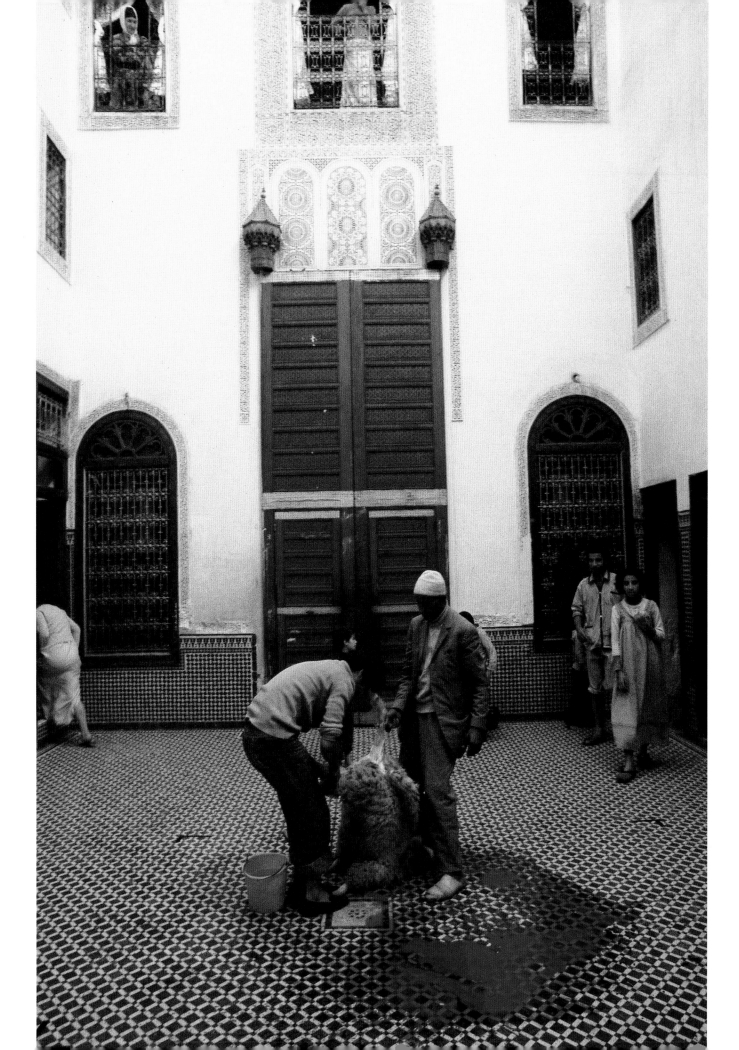

"We argue over stupidities. W. goes down to look for cigarettes. *At the same moment* I am on my way to the pharmacy on Ledru-Rollin and I hear *someone*—an interior voice, or is it really W.'s?—call me, full of distress. I look in the café. A mirror set on a corner returns only my own image, which disappears the moment when, moving closer, I arrive before the acute angle. I feel sick and I return to the house. We embrace as if we'd just lost each other. I don't want to fight with W. ever again. It's too dumb. He works all night to copy his tapes and pack his bags. I go to bed around two. And at eight awake in panic: he has not left, he's going to miss his plane. I try to help him pack the last things. 'I wanted to miss the plane because I didn't want to leave you.' He calls me from the airport. This separation is horrible. I know that for at least a week I'm going to turn in circles in the apartment and then, just when I get used to being alone again, he'll come back."

—She said, "My children grew up with that person. She comes back, she is not evil. Ask all my children who are married and who have had children themselves, and they'll tell you that they slept peacefully, all of them, in the room." There were certain rites to carry out and then that's all, you see? You had to do this or that at such-and-such a period or—not do this or that at such-and-such another period. It's that V___ doesn't have this kind of conditioning at all; me, I had it. And I resisted, I struggled against that alienation—well, fine, I call it that because that touches, that goes to the extreme sometimes with us. I said to myself that it's not now that, finally, after having resolved that question in my mind, that I am going to start asking myself questions anew about it. Thus I did everything to discourage him from following those rites. But at a given moment it was like a fifty-kilo sack of cement on my chest, and that breathing was in front of my nose—mounting, mounting, *mounting*—

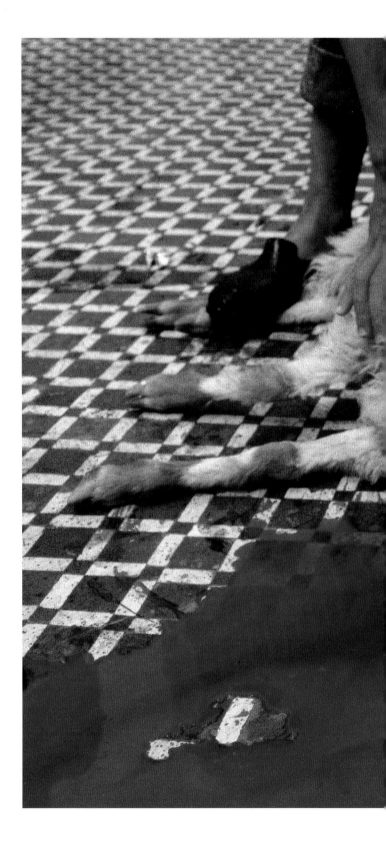

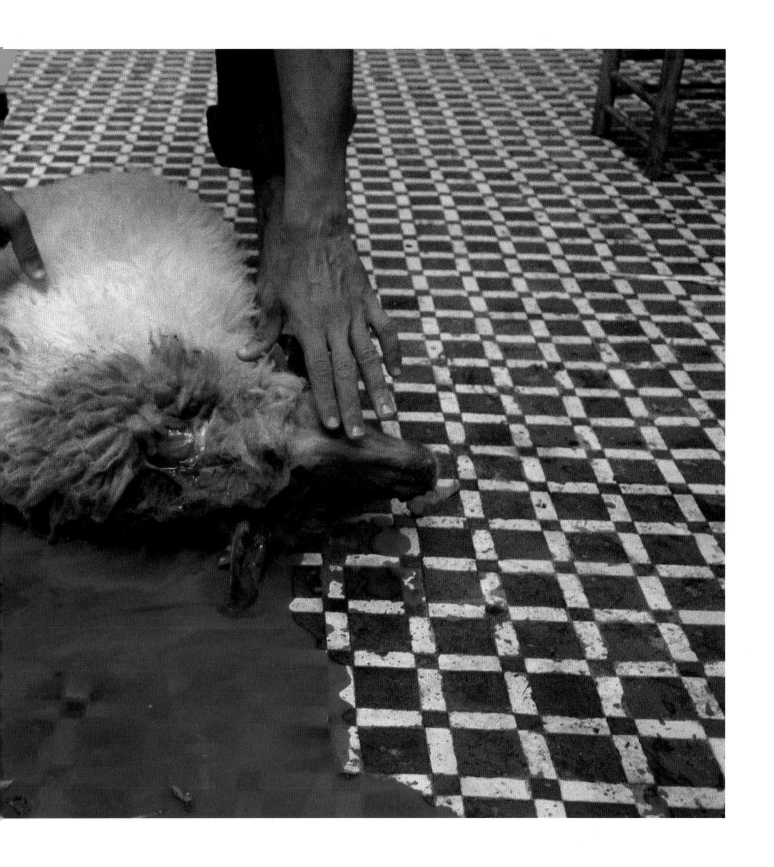

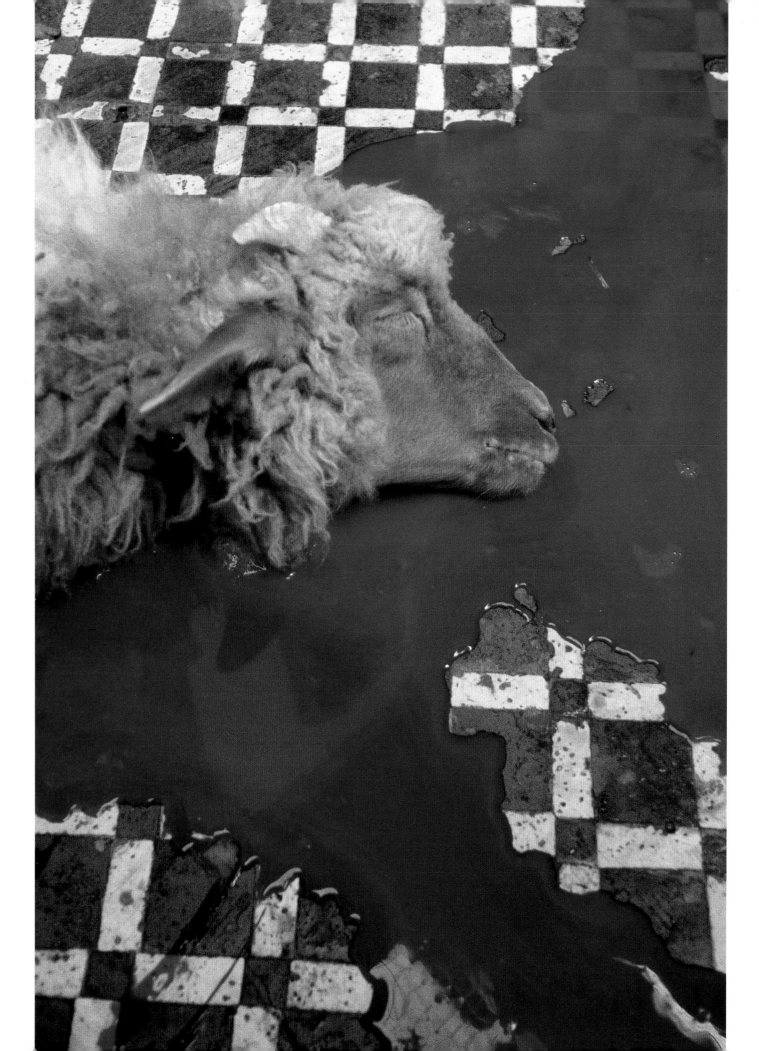

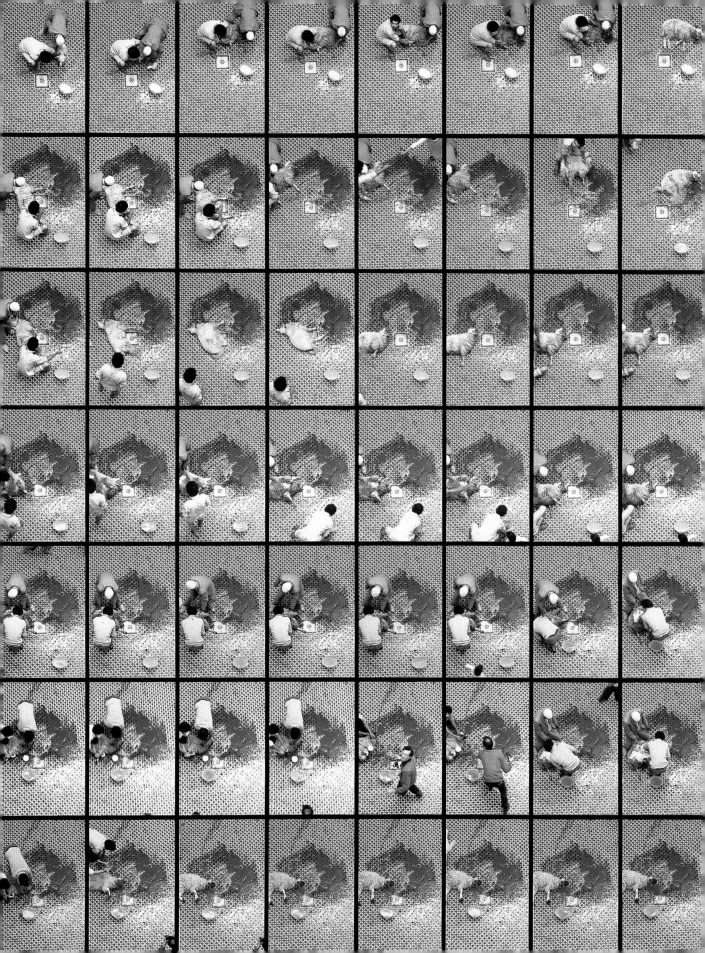

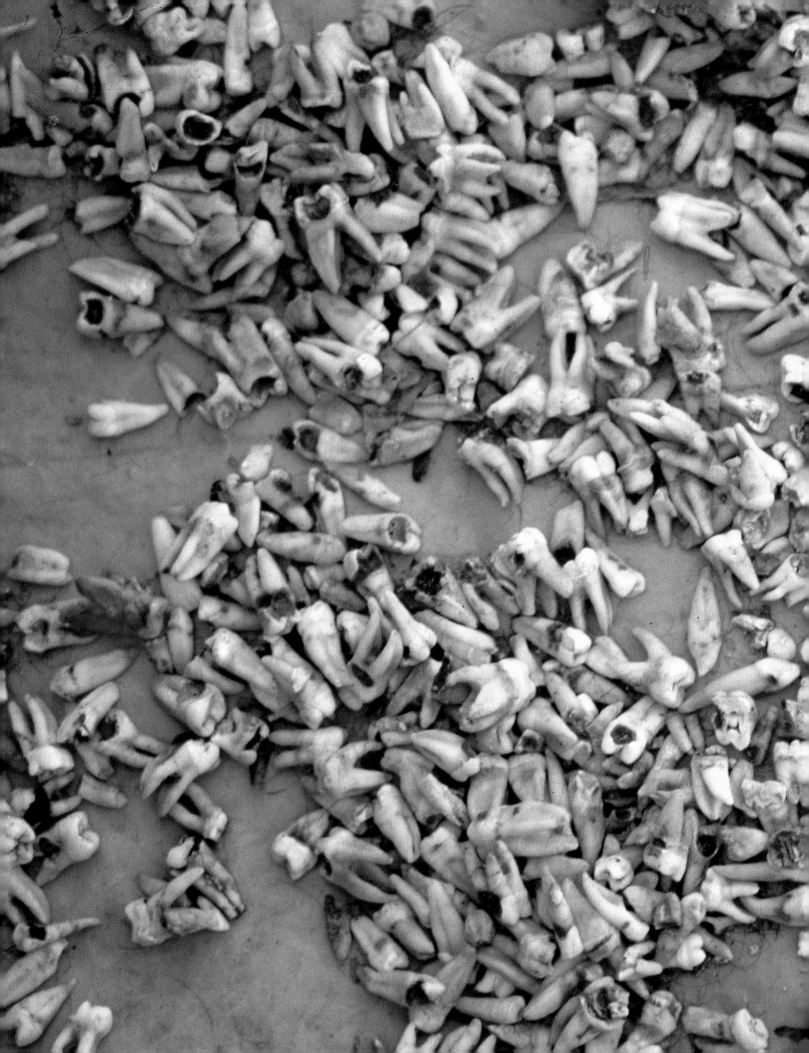

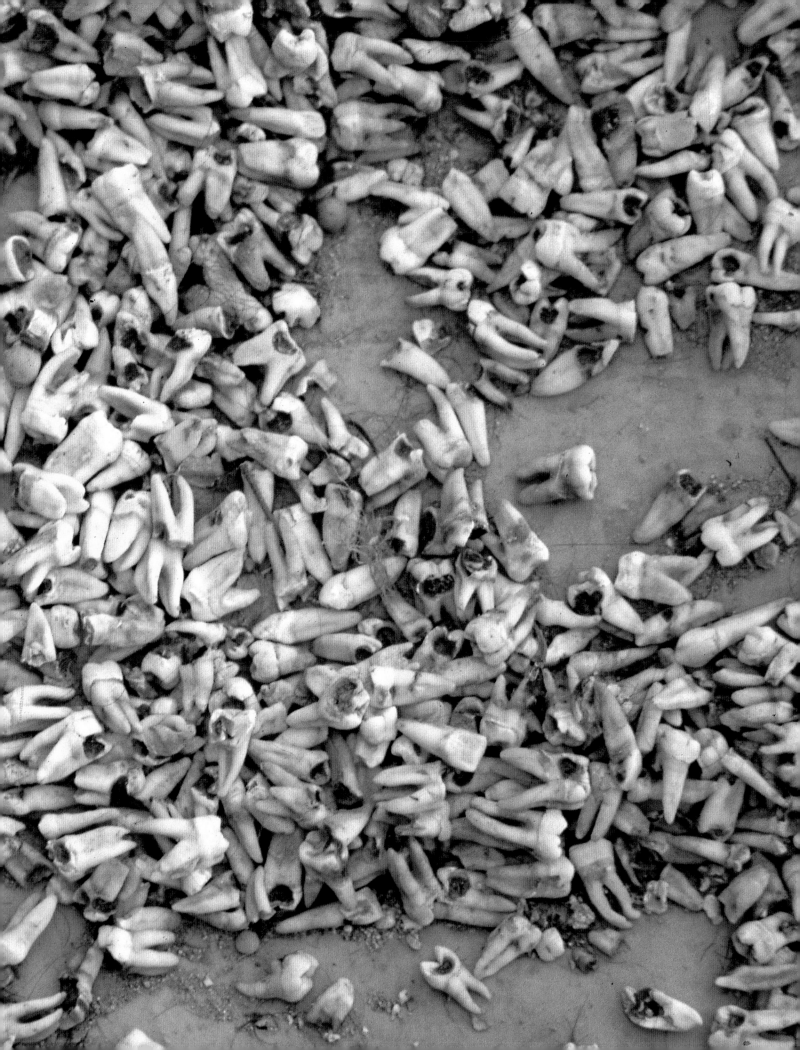

8. The Name

"No one counts the slices taken from a cut loaf."

—*Fassi proverb*

The clatter of the taxi shrinks, leaving only the hirondelles crying like fine fingernails on blue slate. We mount the path through the dead grass to the gate and climb into the field of tombs.

Our feet brush the weeds, the whirling birds call, and on the tape the wind gusts episodically, effacing by strokes these two rhythms. Once he says, "It's four years I haven't set foot in here," and some seconds later, "We go this way." Then: "There's an Arab poet who says, 'Try to walk, try to walk . . .'" He cannot find the word and burlesques tiptoeing for a meter. "He was blind. He said, 'Try to walk gently because the earth beneath—all the earth is a grotto of skeletons.'"

The shrill curtain spread overhead has thickened to become one single cry renewed a thousand times each passing moment.

"And with us, the custom when we enter a cemetery is always to say: '*Bonjour, bonjour.*' Gently. In the heart. '*Bonjour.*'" A little laugh escapes him. "These are customs."

The dusty path turns upward over an outcropping of rock. As if to himself he says, "That will happen to us one day. *Ah oui.*" He laughs again. (*Steps, wind.*) We reach the crest. Two or three white-robed men among the mourners at an open grave beat a monotonous rhythm with their voices, a single, circular phrase.

"I arrived at Fez about four in the afternoon that day, and met the people coming back from burying her. So I had to wait three days. I tell you, that night, with the religious ceremony, and then, you know, the reciters of the Koran, they were there, it was three days of ceremony. I didn't stop crying. I never felt a love toward Hakima. But after her death, I don't know what happened to me. It wasn't love; it was pity. I didn't want her to die. The third day we went to pay her a visit. Three days after the burial the tomb is half open, and it's then we pay our first visit to the dead. They read the Koran,

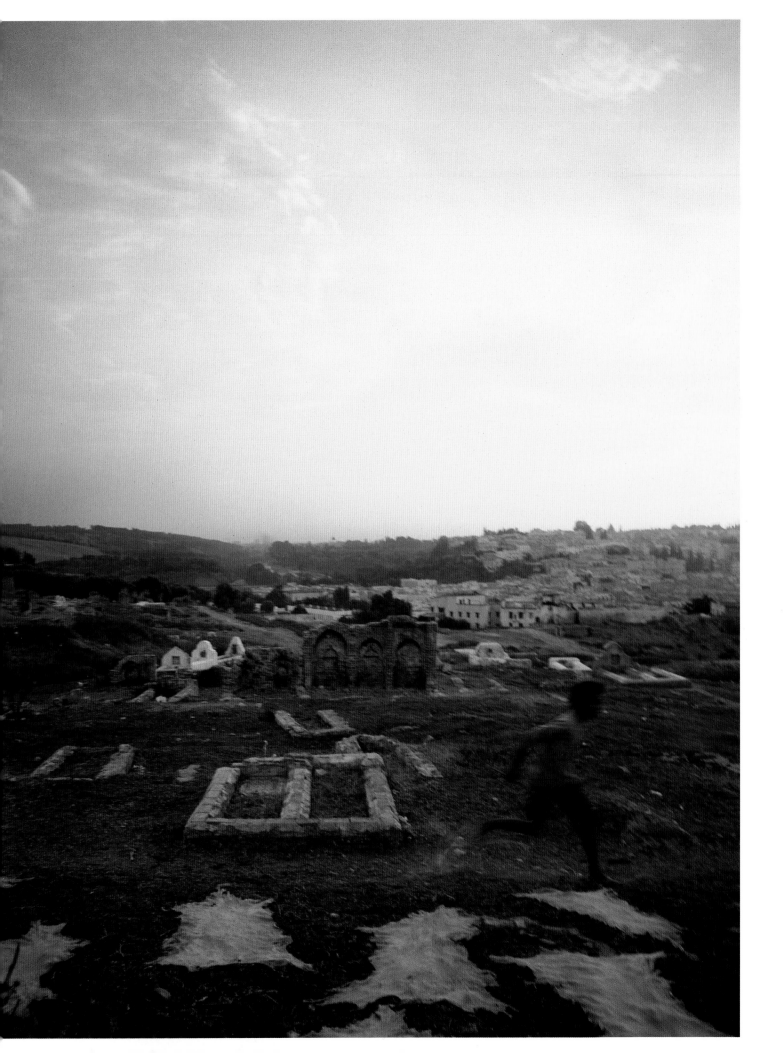

they give bread and black olives to the beggars, or money. So we went to visit her tomb and her mother's. What can I tell you? It was very great. It was—sad, but it was God's will."

The wind brushes away the chant. We leave the path for the high part of the field of white and pastel tombs in tumult. Here and there he bends to read a name and finally pauses at the edge of an open trench teeming with thistles.

"I remember she is installed next to a hole—dug out like that. Not a grave. A big hole, dug like that . . . Not here." He adds in Arabic, "Where can she be, that girl?" He murmurs names, looking this way and that, lost. Suddenly he straightens, staring down. "Perhaps it was never built? Because I heard my sister say that Hakima's tomb was never built."

We stand over a mound of stones roughly sealed with a little cement, impacted in the bracken of thistles. At the head as at the foot, a thin, black shard is stuck upright like a tooth, as on a grave of the high mountain desert, indistinguishable but for these markers, called *sahed*, meaning both "index finger" and "witness." We sit on the neighboring tomb, Hakima at our feet. The other offers me a cigarette. The wind blows out the first two matches in his cupped hand.

"There is a proverb that says: 'Go there; I will rejoin you.' Maybe it's badly translated. But they say, 'Go on, go on, I'll catch up.' " The wind scratches over the voice on the tape. The next thing I can make out is:

"No, no, there was an agreement between them. But my sister always thought, since she first met Hakima, that this little girl deserved having Abdulkader. She deserves! The decision was—the two of them. Exactly a year before. But it's thanks to my sister that I accepted Hakima. Believe me, if it weren't for her, I wouldn't know Hakima. Why did she deny that? I know my sister. I know my sister *very well*. My sister, sometimes you can't, you can't *believe* my sister. And you have to say, that's *women*. My sister is like the moods of the sea, one day calm, one day—" His voice trails away.

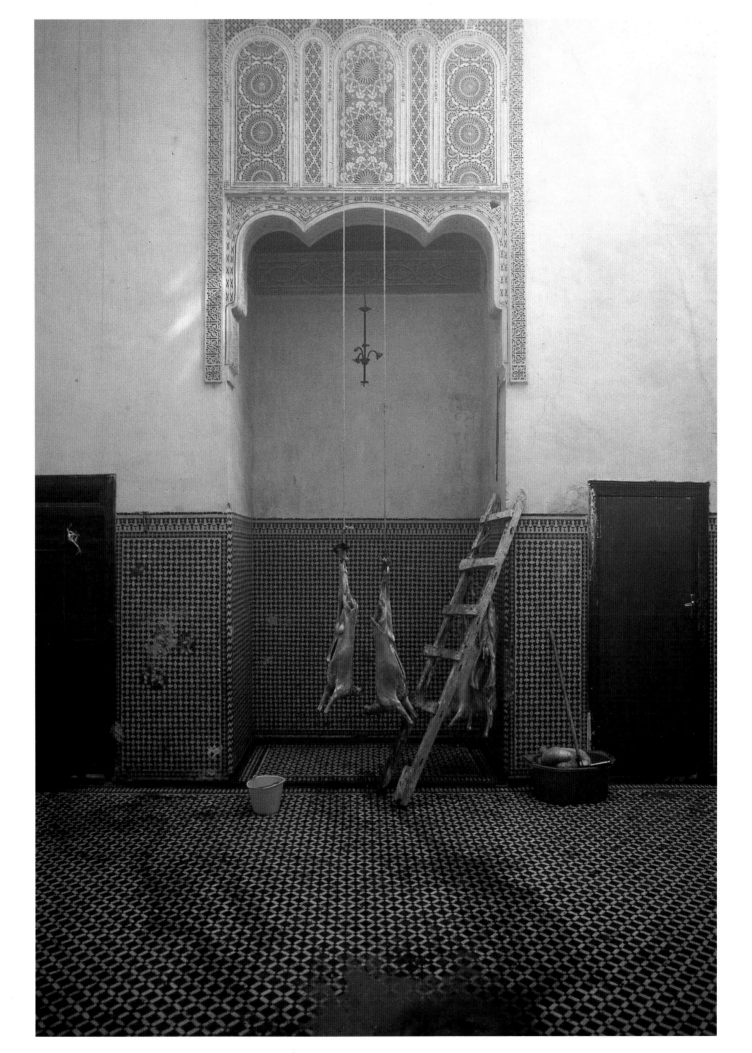

"And because with Hakima I had absolutely no love relationship. I was, if you like, I was pushed. I was pushed. Because I had a —me, also, I had a love: at Sidi Kacem. How did I know Naïma? By coincidence. It was the big feast, *Aïd Kebir*. She was very beautiful, and I adore beauty. You'll have to excuse me, it was—I adore beauty. She was small, in long robes, a dress as blue as the sky. What a girl! I courted her, she was—it was easy. And I knew Hakima—after she had grown up—and I knew Naïma, we grew up together, we spent more than five years together, nobody ever knew. *En cachette*. According to our custom. We did everything. And Naïma—" Naïma or Hakima? "Naïma, Naïma, Naïma! I'm talking about Naïma, not Hakima. The, the, the, the names sound alike . . . And Naïma, when she got a little bigger, she became very beautiful. And very materialistic. All she wanted was money; and I had no money. She began going out with teachers from the *lycée*, going home with them. She began to go farther and farther away from me. And I love her still. So, if you like, that's the principle I knew with Hakima— with *Naïma*. And with Hakima, it was something else. It was a question of family. I did not sleep with her profoundly, no; but—I would even put my sex in hers, never deeply, but you know, *des coups de pinceau*. We did that, yes, even sometimes we—before the marriage contract she was very patient with me. I had the idea not to deflower her until the marriage night. But we did these things, always respecting the limits, certain limits. Later, she wasn't the same anymore. She refused me certain pleasures. I thought she wanted to keep certain things for our wedding night. The last months she refused completely. She didn't want me to find out what she was. The day her truth was going to be discovered, the day they demanded a virginity certificate, she refused. Of course. And beyond that, she was oppressed. Especially by her mother. So you see, only God knows. If there was any tenderness on Fatima's part, I never saw it. I remember one day, the nineteenth of November—19 *May* '77. I came to Fez and we went out together. She said, 'I'm fed up with this life. I'm exhausted. If this route could lead us to your home in Sidi Kacem directly, I'd follow you, once and for all, and never come back.' I even saved the tickets from the bus we took that day. She said, 'I'm tired of being deprived.' That proved she was oppressed. She felt pressed to get out of the life she had. The life she had with her mother. And on all other levels she was not satisfied. She was deprived in every sense.

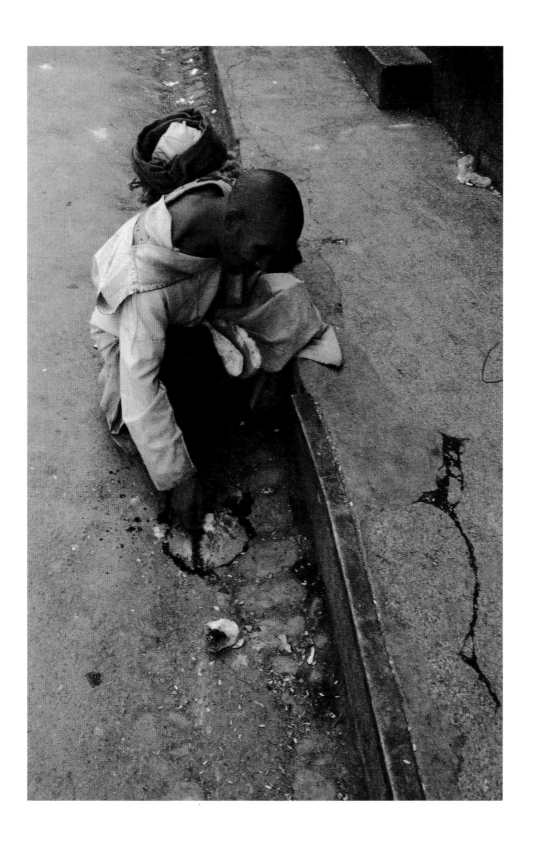

"From what I learned, outside the family, from outside the two families, Hakima had a love I do not know to this day. A boy. He was good to her. After her death I felt that. And I think the poor girl lost her virginity with this boy. It had to be. You know, for a Moslem, virginity is very important. And you remember the problem I had with Hazira—I mean Fatiha? It's the same problem." And Sliman, who cried for two weeks after her death? The police even took away his service arm. "Sliman?" His voice cracks. He watches her grave carefully. "Sliman is very sensitive. Maybe the most sensitive man I've ever known. But you think he had a relation with Hakima, a sentimental relation? No, no, no, no, no, no, no." She visited him all the time, going back years. Why had his sister not signaled the girl's defects until after the marriage contract? The contract broken, Hakima silenced, divorced; no one would listen. "No, nonononononono. No. No, no, no. Sliman, uh, Sliman respects little girls very much. He is sensitive. But no, my God; he loves them like his child, if you like, like that. But he had no relation. And I'm talking to you seriously—I'm being frank, because if there was something—I feel you like myself, I'm very curious. And I—listen, I will give you the proof of how I felt she lost her virginity, according to what they told me outside the family, in the café next door, the boys there, they know Hakima, and they said how each time they found them together, this guy on his motorcycle with Hakima at Sidi Harazem, the swimming pool. Where he—there. He had her. Or else he was a neighbor. They said one night he spent the night with her, when Fatima wasn't there. He climbed the wall. And I don't know that person, this boy, to this day. And I asked, I asked. Because I'm afraid of nobody, I tell you the truth. If I felt the slightest suspicion—" He whispers. He had not lifted his eyes from her grave. "But I felt nothing."

The wind, the hirondelles, the wisps of klaxon return. The other makes a move. I look up.

"Oh, I swear to you that I will keep that between us. Note well, note very, very well that Hakima lost her virginity with the boy I told you, who I don't know. To this day I don't know. Because—I wasn't profoundly in love with her to ask the cause. She's dead. I'm telling you the truth, nothing but the truth. She's dead—because—we slept together, but I never touched her, never once. I never penetrated her with my machine. No. Because I said to myself that Hakima would one day perhaps be my wife, and I'd leave her virginity for the chosen day. For a woman it's difficult, you know, the girl, when she loses her virginity, nobody—she's a *qbah*. You know this word? *Qbah*. Whore. Even my wife, I found her—deflowered. My woman, *had*. And I accepted her." He laughs nervously. Standing, we dust off our trousers. "You remember now? Note well the, the— . . . We went very, very far." Again the tight laugh. "Projections." We reach the path. Suddenly he speaks.

"Me, personally, I think that she was a virgin. Perhaps. You never know. But I believe. *She was a virgin.*"

I replay the tape many times: it is as if he addresses the wind. We descend and leave the cemetery. A hundred meters, the distance to the bus stop, pass without a word; then:

"You know, his name was *Kamel*. They told me his name. but I never laid eyes on him."

We spread our picnic at the edge of the reflecting pool at Versailles, an avenue of water set on the axis of the palace, bisected by another straight canal, an artificial lake in a squared stone basin, a great cross traced on the wooded park. Some children strew potato chips on the surface, attracting a flurry of once-royal carp. The fish lunge and the children strike with pointed sticks. For a moment, the water boils with stabs, chips, and eyes. Even blinded, the carp return again and again, as each new lure is sown, for more.

In the winter, she leaves. Next day—that date—I tear a story from the wire to save:

CAIRO 14 FEB (AFP): ALL ARRIVING FLIGHTS HAVE BEEN DIVERTED TO AIRPORTS OF NEIGHBORING COUNTRIES, AN OFFICIAL SOURCE ANNOUNCED THURSDAY NIGHT HERE, AS A SANDSTORM RAGED OVER A LARGE PART OF EGYPT, REDUCING VISIBILITY. MOREOVER, A VIOLENT TEMPEST OF HAIL HIT ALEXANDRIA THURSDAY AFTERNOON, FORCING AUTHORITIES TO CLOSE THE PORT TO SHIPPING. METEOROLOGISTS FORECAST THAT THE STORM, WITH WINDS UP TO 55 KM/H, WOULD LAST A WEEK.

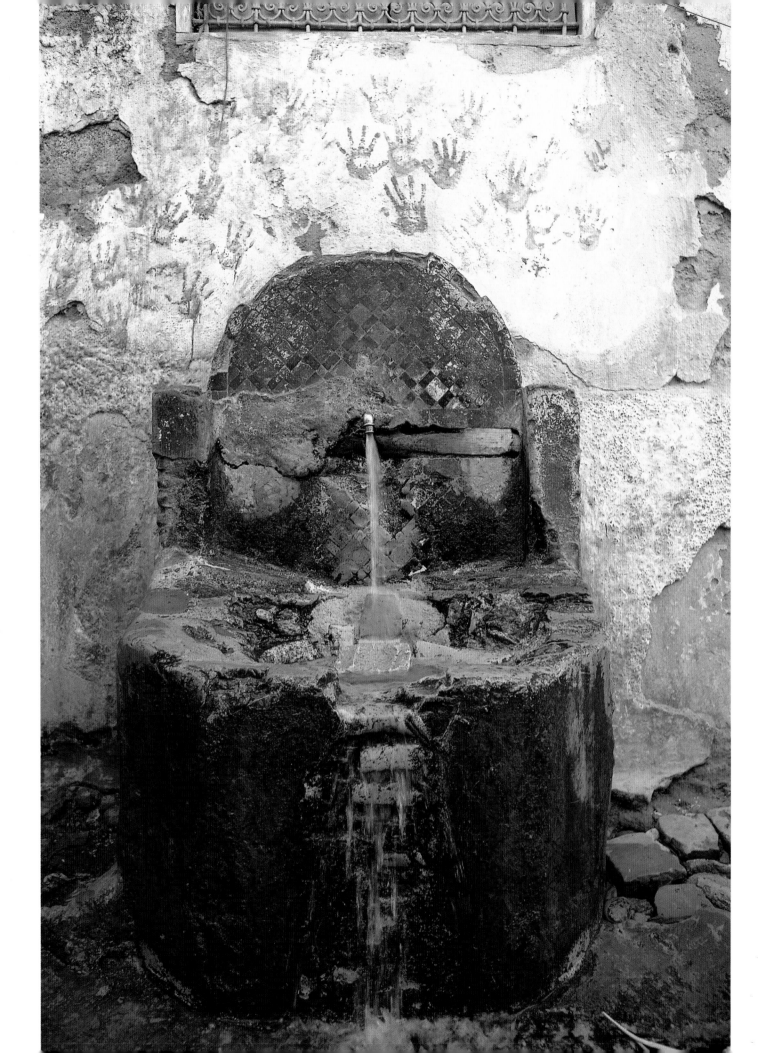

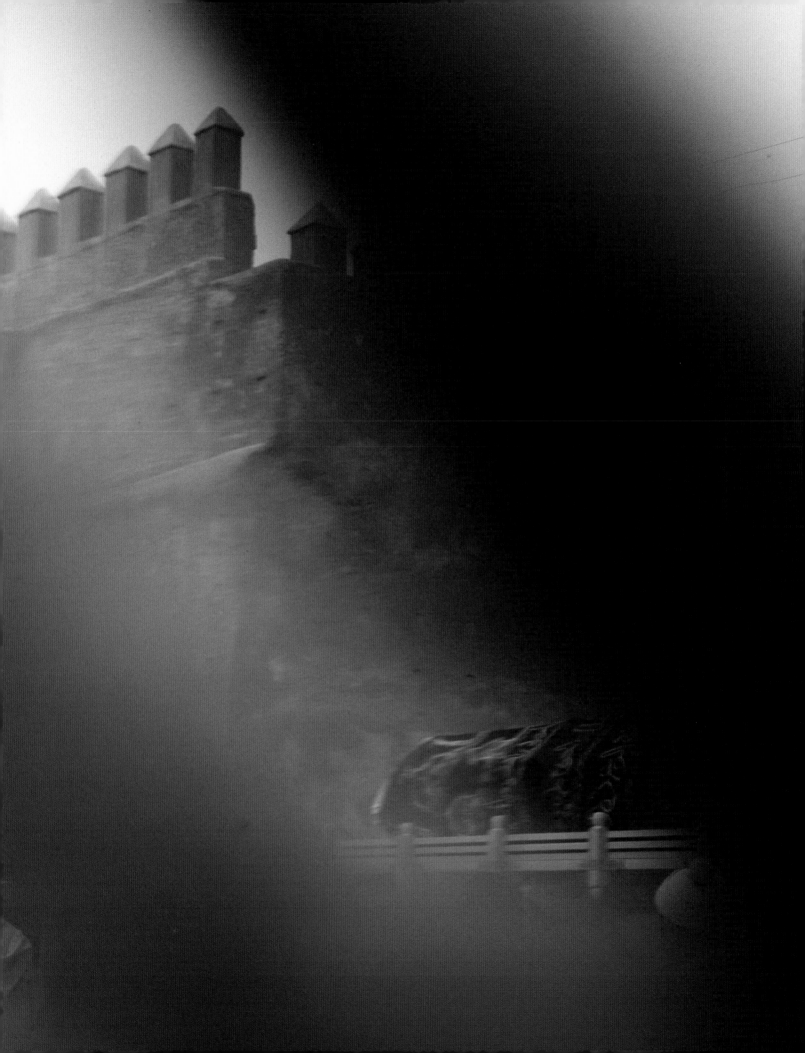

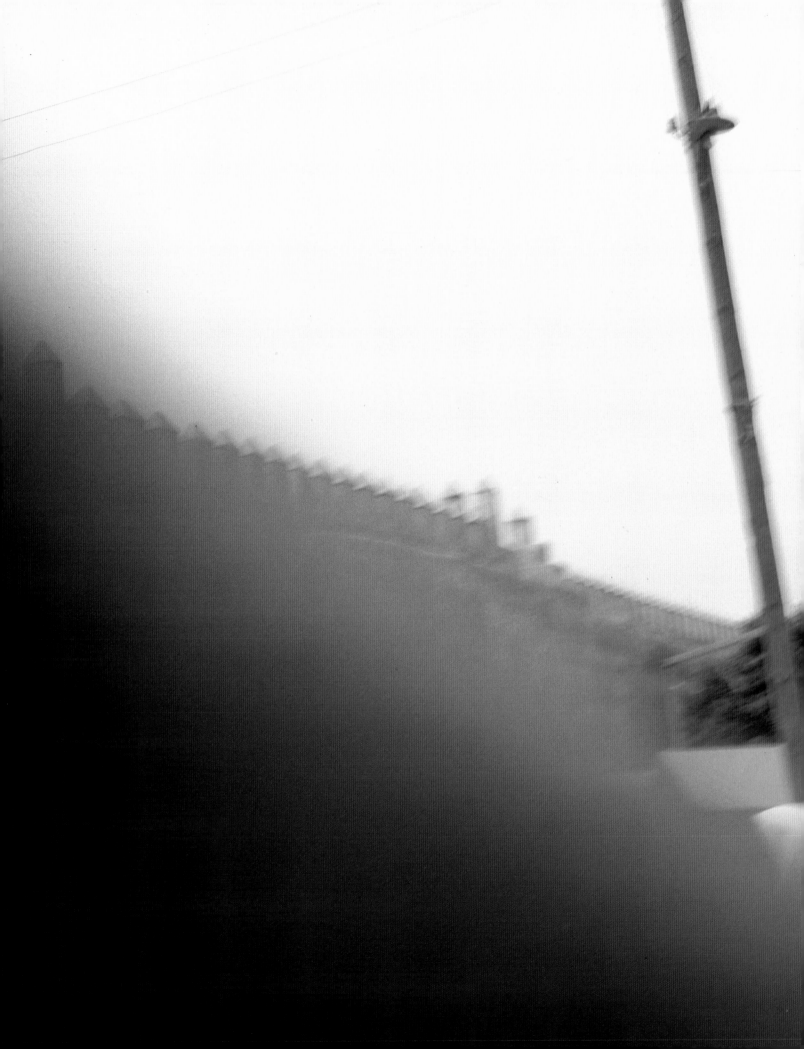

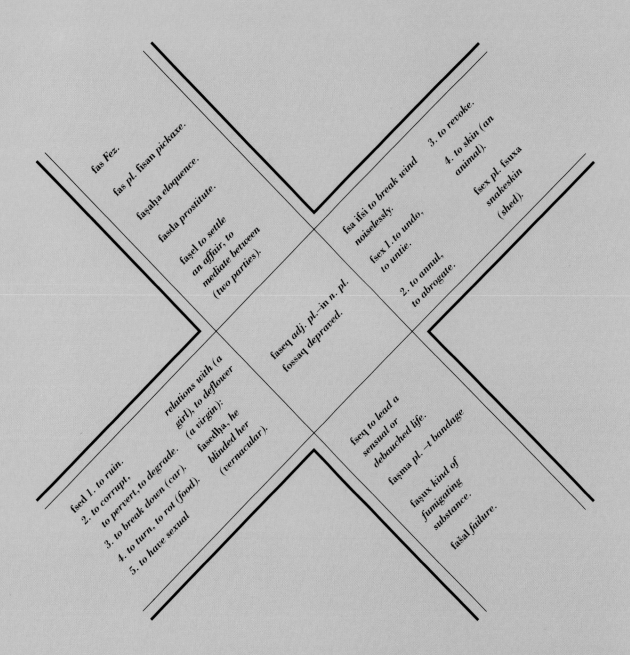

fas Fez.

fas pl. fisan pickaxe.

faṣaḥa eloquence.

fasdla prostitute.

fasel to settle an affair, to mediate between (two parties).

fsa ifsi to break wind noiselessly.

fsex 1. to undo, to untie.

2. to annul, to abrogate.

3. to revoke.

4. to skin (an animal).

fsex pl. fsuxa snakeskin (shed).

faseq adj. pl.–in n. pl. fossaq depraved.

fsed 1. to ruin.
2. to corrupt, to pervert, to degrade.
3. to break down (car).
4. to turn, to rot (food).
5. to have sexual relations with (a girl), to deflower (a virgin); fasedha, he blinded her (vernacular).

fseq to lead a sensual or debauched life.

faṣma pl. –t bandage

faṣux kind of fumigating substance.

faṣal failure.

9. Jbel Zalagh: The Tape

The *shuwwafa* (*The first sentences exchanged by the guide, Hamid, and the sorceress are incomprehensible*: t.n.): . . . and you've become a field that others use and profit from. You've become the field of another. You can't permit it. Stop it. This girl you take out, who you spend money on, you think you'll find her intact? Impossible. She goes out with you, she'll go out with others. Even if you play in water she catches you with two hands. To say she is fine—no, she's not. That she'd be good to found a family with and make children—no. Fidelity? None. You consider yourself free? Then you must have a free woman, a free one you need not control. Neither parents watch over her, nor family, nor tribe. How can you supervise her at home? And what's more, there is someone with her, his name is Mohammed. Look, he's standing, there he is. (*She indicates the coin.*) And there you are, you have your arms crossed, she crosses them for you. So you see? You are not at ease. The thing people guard jealously, she's given away. (*Phrase or word incomprehensible.*) Have you written a *herz* for her?

—*No.*

—She cries, she weeps. Fear nothing, she is in your shoes. She depends on you. And you depend on her. The girl basically is not bad. It's the mother who makes her that way. . . . What is your work, my son?

—*I'm a shoemaker.*

—And right now, what is your work?

—*I have none.*

—We do not want you to stay here in Fez. We want you to go away, to travel. You'll stay as long as you want here, but you'll end up abroad. You must set out. Stay free. Don't tie yourself up here. If you do, you will be thwarted. And this girl, have you given her sign of your face?

—*What?*

—Sign of your face: the photo. You haven't given it to her?

—*No.*

—Watch out if one day you have it on you. Don't give it to her. This girl, she's gone to see a *faqih* already. And he asked her for your photograph. If you give it to her you will become like a dry branch. Ah, the route smells sweet, Sidi Mohammed. It is absolutely perfumed. Her, she wants you. She's blind in you. Even if she trifles. But you're not made for her. God will give you the one who merits you, but your destiny, it is not her. You'll dine well in the evening. Now you're going to tell me that you're bewitched. No, you are not. But soon God will bring you ease. And all will go well. Find yourself an orange like this one here before me and peel it and eat it. Not one in the morning, this isn't it; and one in the evening, that's not it. That's all, son.

(*The shuwwafa turns to C.*): Even if you marry, you'll divorce. Her character is not right. Because whatever he may be, whoever he may be, no man can please her, not for long. Moslem or Christian, the same. Him (*indicating the photographer*), he is a Christian, isn't he? A Christian converted to Islam. Live far from him, elsewhere or here. That man has another wife, another woman, whom you follow. That woman is an *'afrita*, a demon. You, you have but one word. You do not deceive, you do not betray. How can you live at the side of the other? The other woman is Moslem. Beware of her. And also of him. Give her no respite. Neither for her, nor for the man. Whether you wish it or not, she cuts into the route. You have seen the signs on the coin? Him, he adores you, It's as you wish—even if you mount to heaven, he will follow you. You are at ease. He will follow you if you wish and will not follow you if you do not wish. And you will live with him without children. You will live artistically, in beauty. And this sorcery, nothing to do. If he does good, you will be with him. If he does evil, you'll be with him. (*Entire sentence indecipherable*: t.n.) And him, he never tires of her. Even if you mount to heaven. As long as you do not change. Stay well, such as you are,

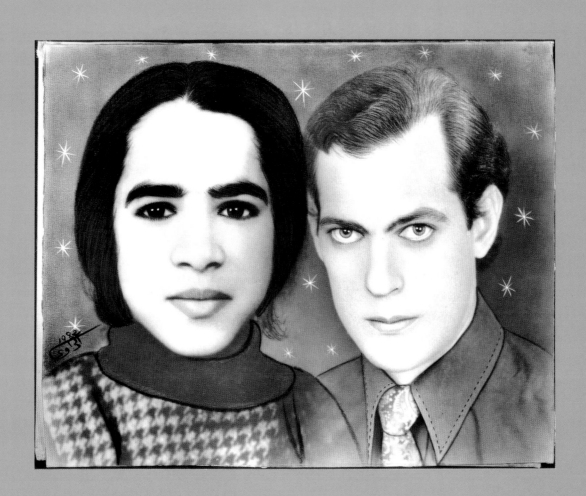

counting on God. If you tire he will take you on his back. And the situation attracts you.

(*Another dirham.*) Hamid: *Again, go on, Madam.*

(*To the photographer*): No matter what girl he sets his sights on, with her he has problems, to the point that when he has work he can no longer do it. Before, he followed a Moslem. There is a woman who shut the door to him. It is a married woman, from here. Everything thwarts him. There where he opens his hand, the doors close. And he will not continue with that Moslem. He will return to his own.

—*To his own woman?*

—Yes, to his own. Sidi Mohammed, it's that he is bewitched. He must open, he must break that—that is, he is under a spell, and it's necessary that he break all that. They have written *tqaf* for him, so that he does not marry. He will not marry, neither with a Moslem, neither with a Christian, nor with any other girl. (*She looks at the coin like a small window, an aperture.*) He has his hands on one, nude, a nude woman, you see, it's a blonde, very blonde and beautiful, but in spite of all that he is going to let her go. He does good but this good returns to him in evil. He is bitten by it. Even if he is *nezzarani* he does good. He is a man among us. He is under a spell. He eats of it. Because of his property, his assets. It's a maid at his house. It's a maid who works for him.

(*The translator pauses: There was a day when we were still living in Ziat in the Medina. And Fatima was still the maid at our house. In addition, it was one of the rare days when Fatima was very happy, very serene. In jest we said to her, Fatima, if we find an American for you, your age, you know, who speaks a little Arabic, and you know how to say a few things in English, and all, that'll work? Her reaction was—she half undressed; she said, but that's possible, you think I'm old? Look at my breasts! We both had our hands all over her buttocks and her breasts—and Patti at that moment, she said to her yes, Fatima, you have practically no wrinkles on your face, you're young, you're still attractive. At this moment we discovered the scar that*

she has on her, the whole length of her stomach and that she had us, in fact, well, she told us it was the scar of a Caesarean—but you know the rest of the story. And then she made a very funny joke, she said, look, I have a derrière devant, in front—but also de vent, *of wind— and a derrière de l'air, of air. And it's true if you look at her stomach, it's really one—yes, it's swollen and then there's this scar right in the middle, that makes a melon that's missing a quarter, you see, thus a derrière. But what really astonished me in all this was that she participated, you see, she was party to the joke but she wasn't joking a hundred per cent, it was—there was that, a part of—perhaps, you know?*)

As we leave the *douar*, the wind drives down the first drops. During the interview the sky metamorphoses into a great roll, like the edge of a duvet pulled over the horizon, advancing and covering the concave city. A dog, hidden by the belly-high grass in the middle of the field, flees. Evening falls all at once, the sky fills up with smoke. The Medina's lights are answered by strands of lightning discharged by the shroud. No thunder; only the wind fills the sound track. We reach the car on a run and slam ourselves inside under an icy deluge that hammers silent our gasps and cries. Darkness.

KML

kmal, kmala (cons. *kmalt*) 1. completion (v.n. of *kmel*) *f-le-'siya 'andna wahed d-dyafa dyal kmalt d-dar.* In the evening we're having a reception to celebrate the completion of our house. 2. rest, remainder. 3. end, ending (as of a story).

-*kmalt le-'tiya* final answer, with attendant ceremony, of the parents of the girl whose hand has been asked in marriage.

kmama pl. -*t* muzzle (as used on a dog).

kmel v.i. (v.n. *kmal, kmala*) to end, to come to an end, to be finished.

-a.p. *kamel* pl. -*in* 1. complete, entire. 2. (with art.) God. 3. all.

"Rejoice O lady and continue to rejoice,
The Piercer has come to you from the Beni Ulîd."

—*Women's song to greet the Piercer, ordered and paid by the bridegroom to break the hymen in his place*

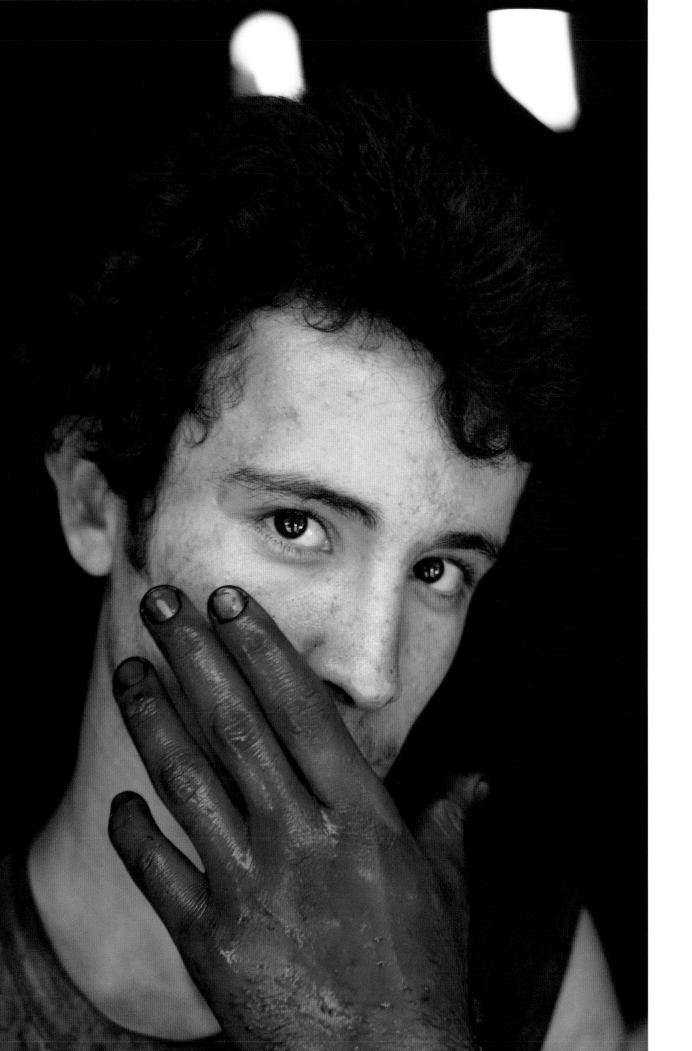

Distributed in the United States by Farrar, Straus
and Giroux. Distributed in Europe by Nilsson &
Lamm, B.V., Netherlands. Distributed in the United
Kingdom by Secker & Warburg, Ltd., London.
Separated, printed and bound by Everbest Printing
Company, Ltd. Hong Kong

First published in Great Britain in 1991 by Martin
Secker & Warburg Limited
Michelin House, 81 Fulham Road, London SW3 6RB

A CIP catalogue record for this book is available
from the British Library
ISBN 0 436 20036 8
Editor, Mark Holborn
Book design by Roger Gorman

To Carole.
I thank the members of Hakima's family and her
friends who helped me to record their story; and
Abdenaïm Ezzaim, Hamid Hayou, William McCray and
Raja Reinking, my collaborators in Morocco. I am
grateful to Carole Naggar for, among all else, permis-
sion to adapt texts on pages 32, 116, and 138 from her
writings. I am indebted to Paul Bowles, Dalu Brunori-
Jones, Peter DeFrancia, Mark Holborn, Romeo Mar-
tinez, Jean-Luc Monterosso, Thomas Neurath, Mi-
chel Nuridsany, and Dennis Stock. Nadia Tazi opened
my eyes to Morocco. Without Christine Woodall the
book would not exist.